MW00915677

DARK GALLERY

PENDERGASTIAN ARTWORK

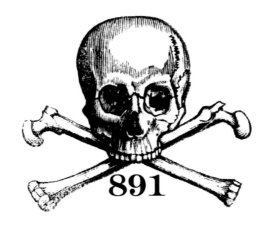

891

CHRIS ROYAL

Copyright © 2016

All rights reserved. No part of this book may be reproduced, stored in a retrieval system, or transmitted in any form or by any means, electronic, mechanical, photocopying, recording, scanning, or otherwise, without the prior written permission of the artist/publisher.

Permission:

Preston & Child characters copyright © 1992 -2016 by Splendide Mendax, Inc. and Lincoln Child. Used with permission.

Disclaimer:

All the material contained in this book is provided for educational and informational purposes only. No responsibility can be taken for any results or outcomes resulting from the use of this material. While every attempt has been made to provide information that is both accurate and effective, the author does not assume any responsibility for the accuracy or use/misuse of this information.

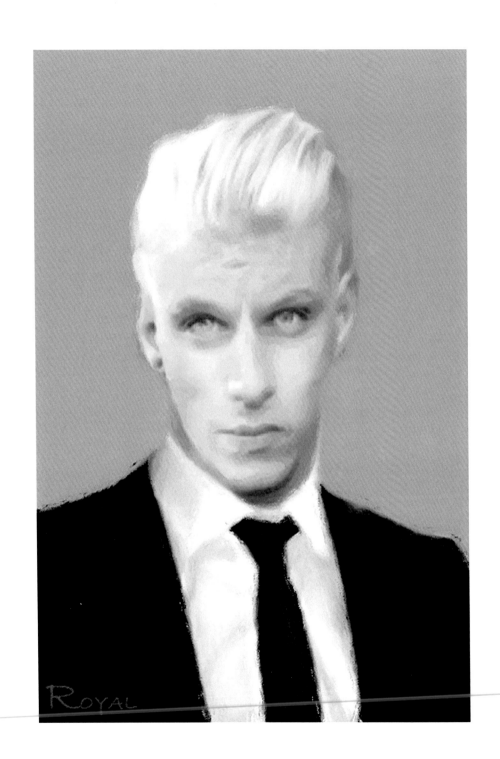

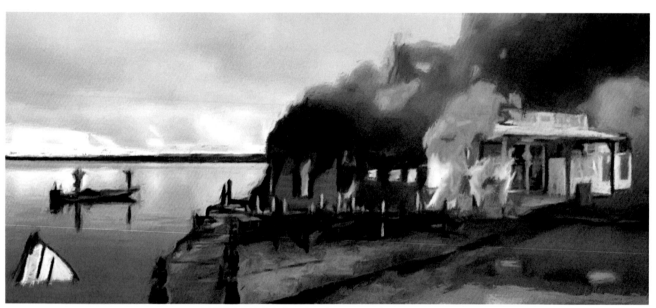

TINY'S BAIT & BAR

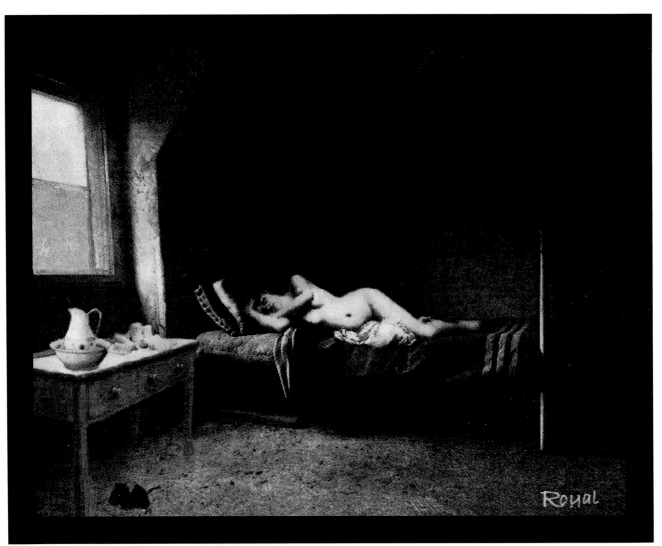

THE BLACK FRAME

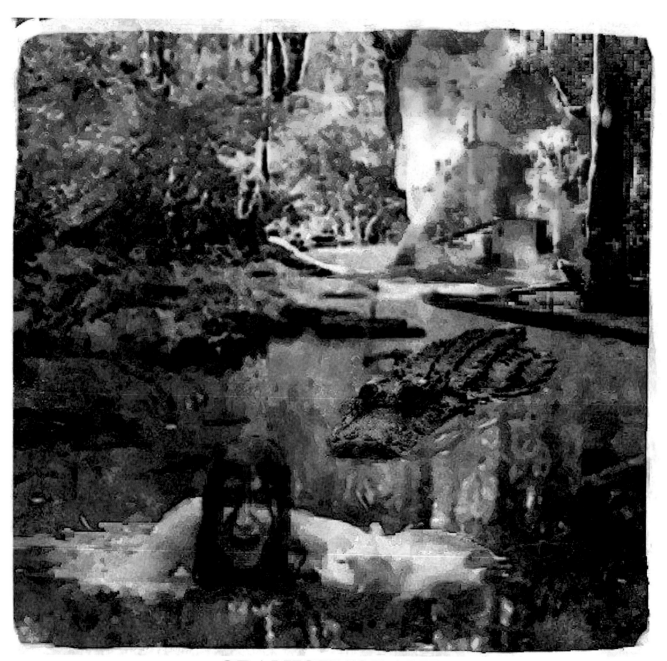

SPANISH ISLAND

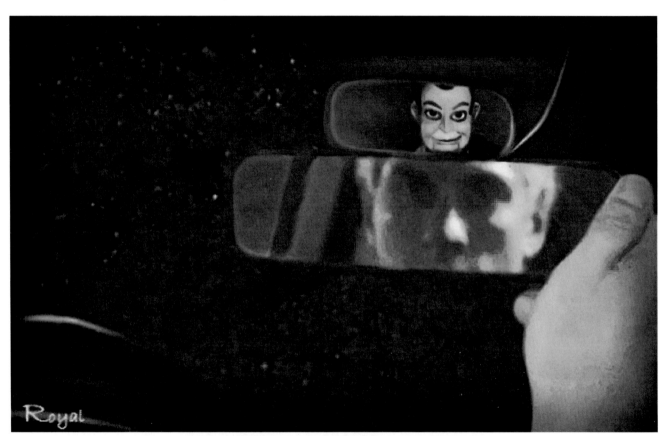

SLAPPY RIDES ALONG

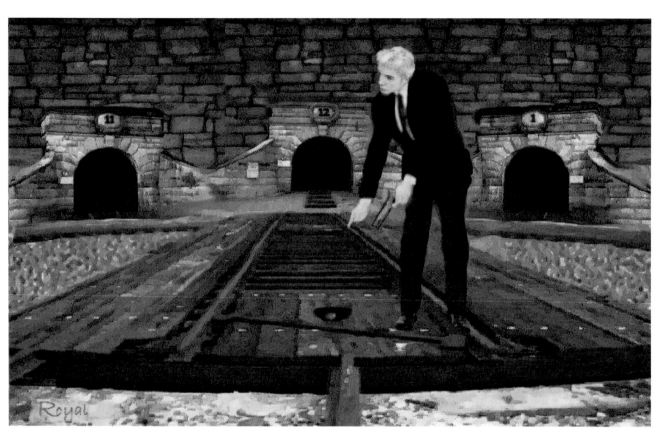

THE CLOCK

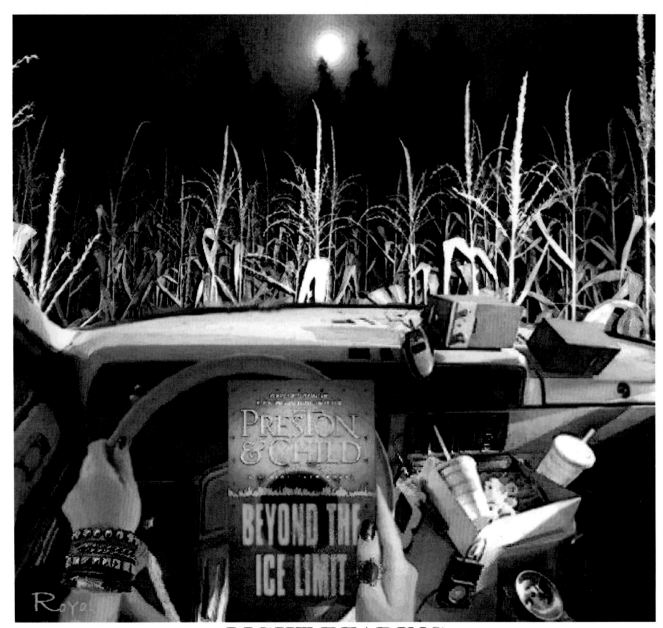

LIGHT READING

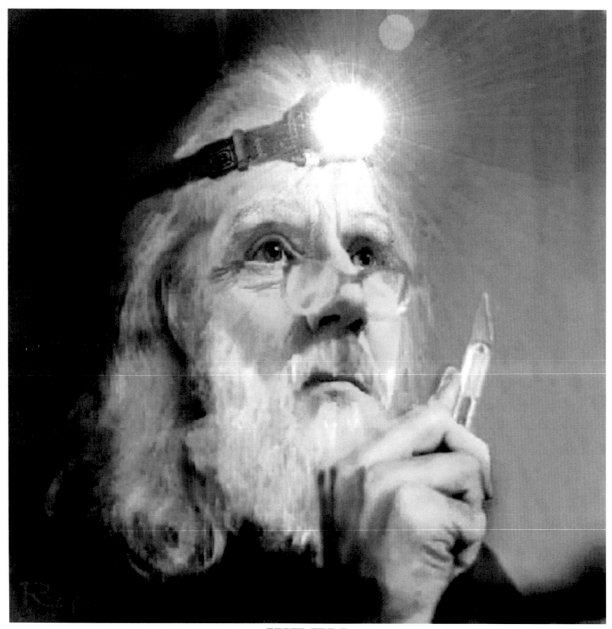

WREN

A FITTING END

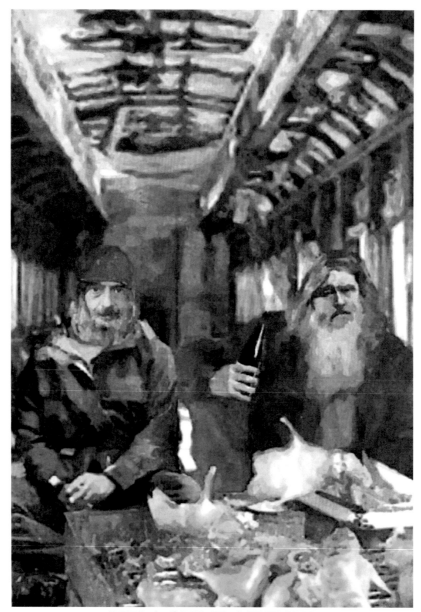

TRACK RABBIT

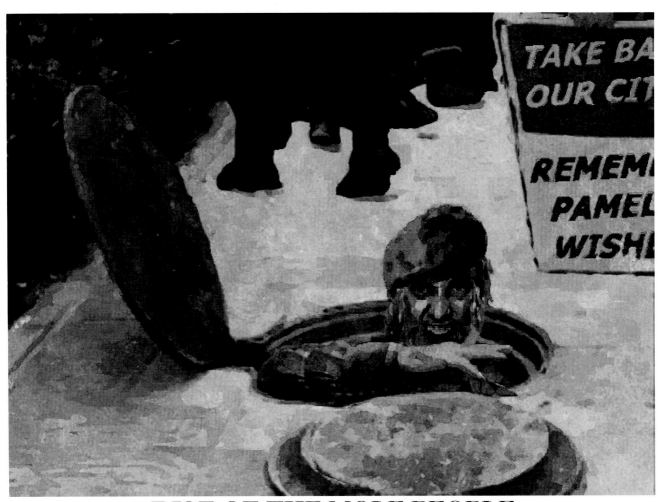

RISE OF THE MOLE PEOPLE

THE TOOTH BOX

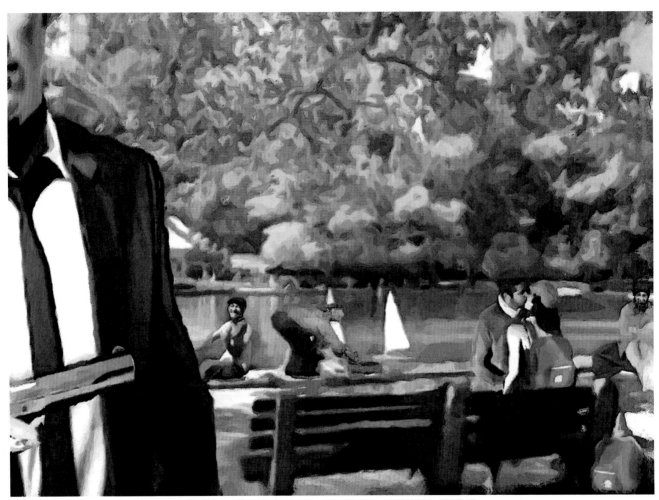

WAITING FOR HELEN

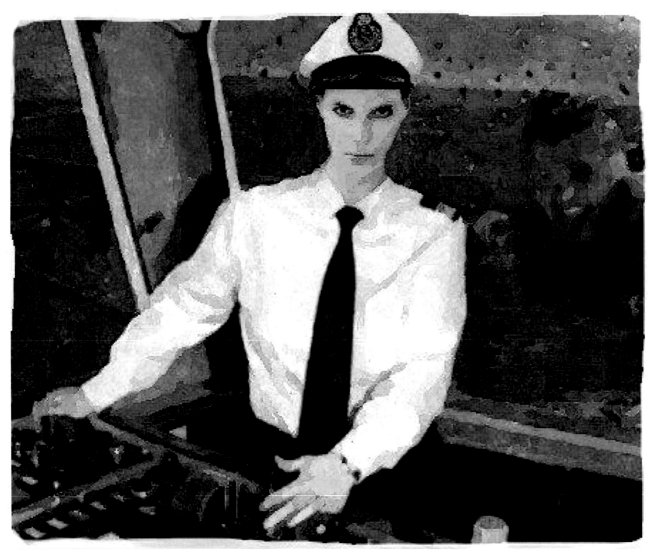

THE LOCKED BRIDGE

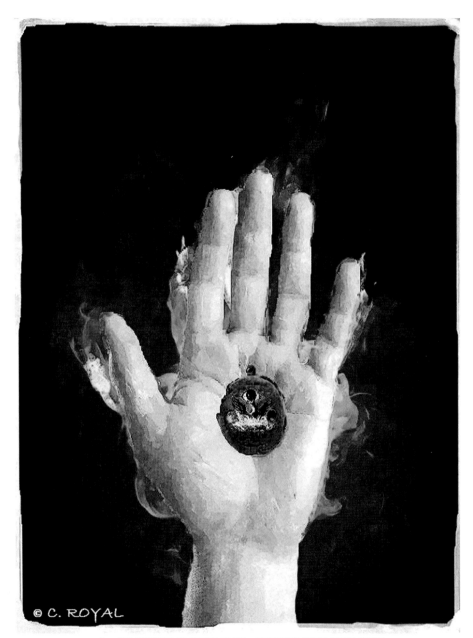

© C. ROYAL

A BURNING PENDENT

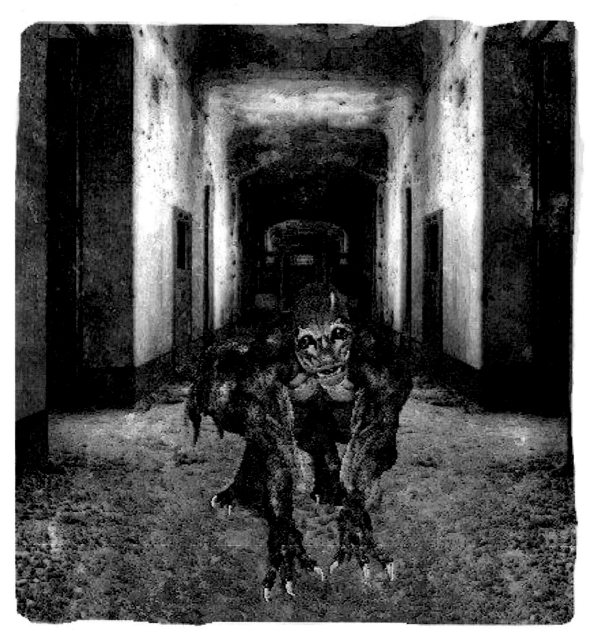

LURKING HORROR

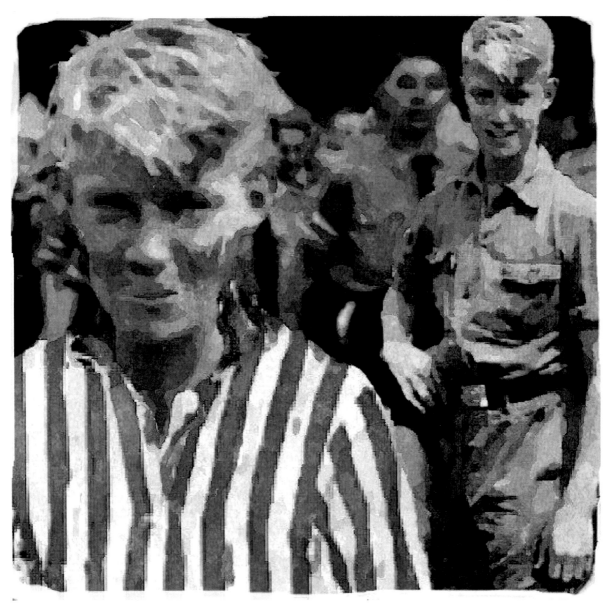

JUST A NUMBER

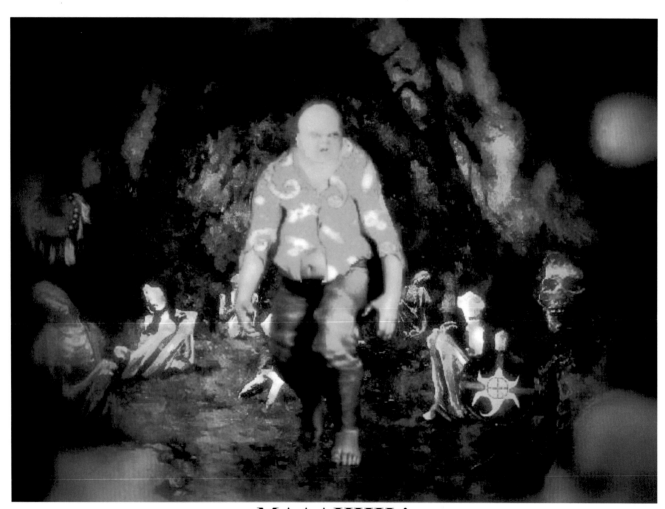

MAAAHHH !

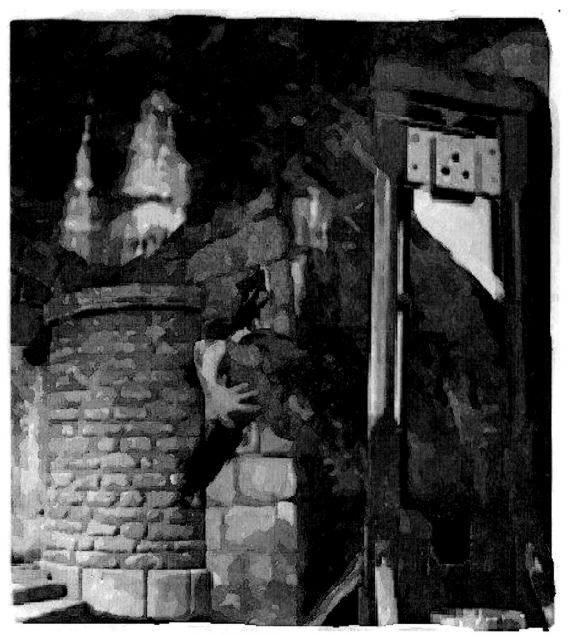

MOVIE PROPS

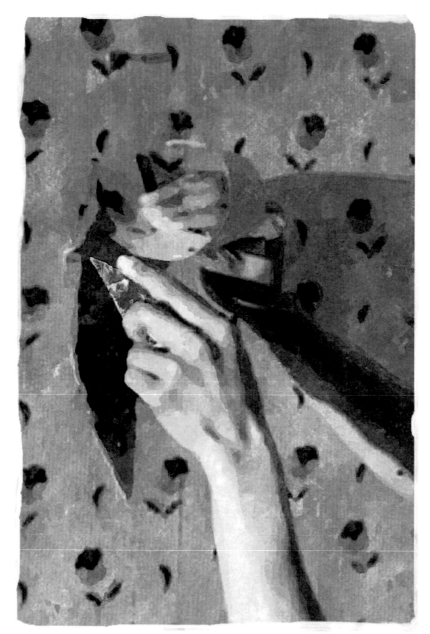

STEEL WALLS

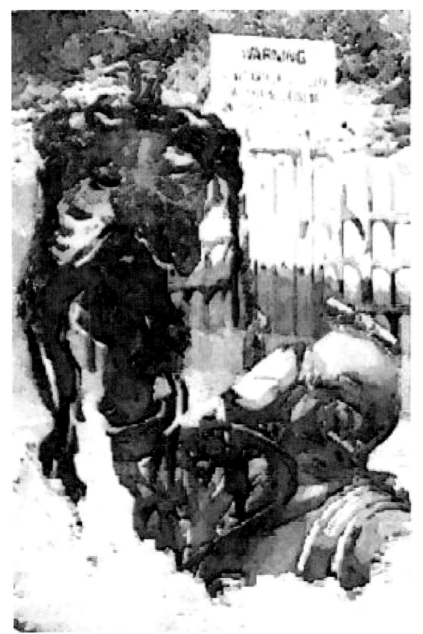

FROM THE DEPTHS

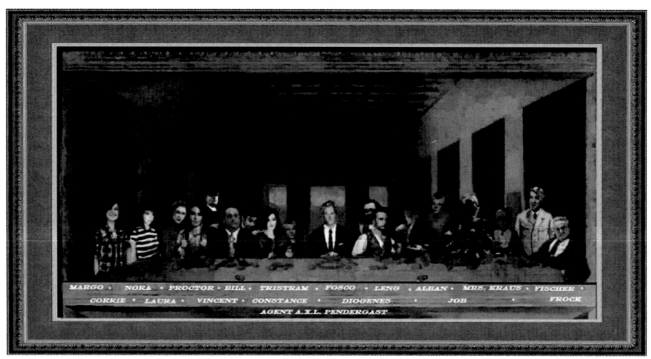

A LAST SUPPER

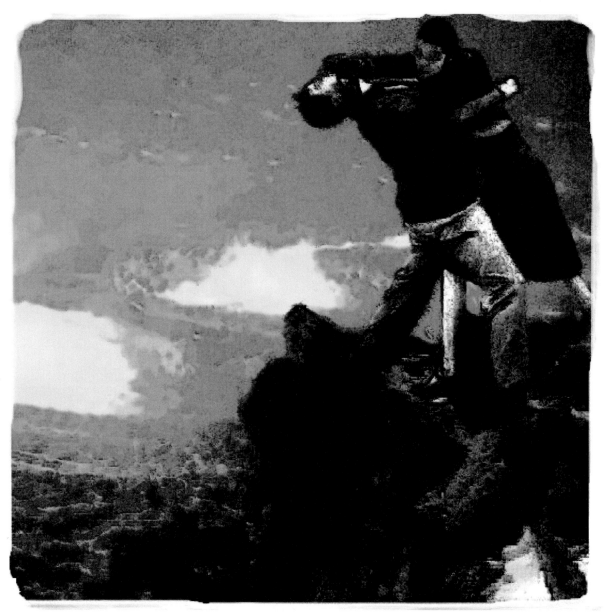

MOUNT STROMBOLI

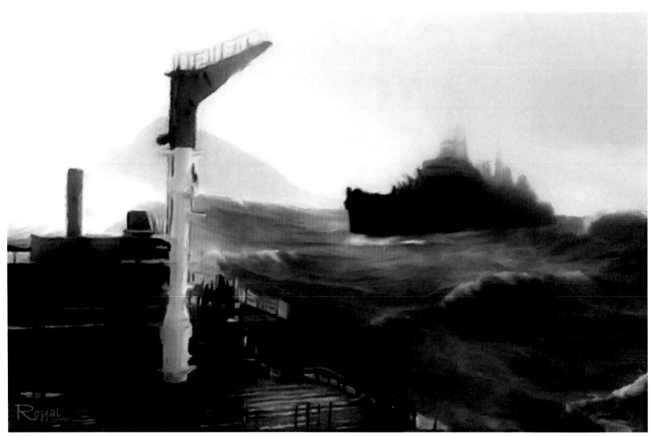

THE ICE LIMIT

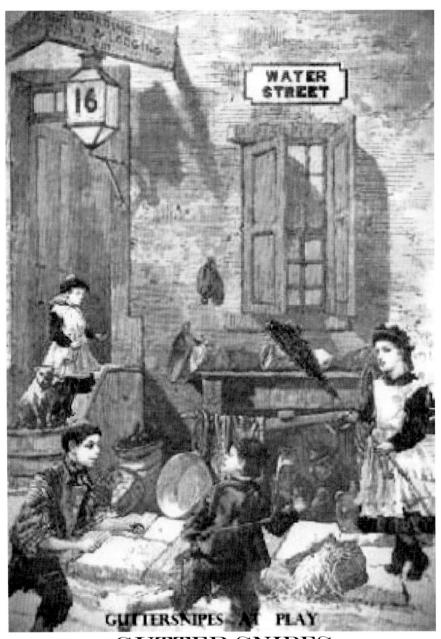

GUTTERSNIPES AT PLAY

GUTTER SNIPES

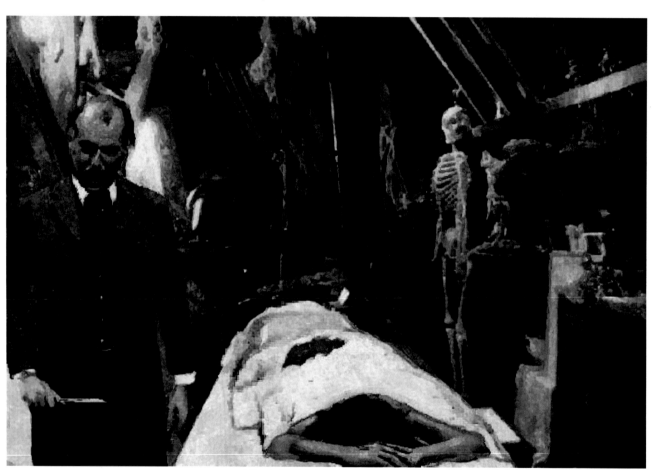

LANG'S LAB

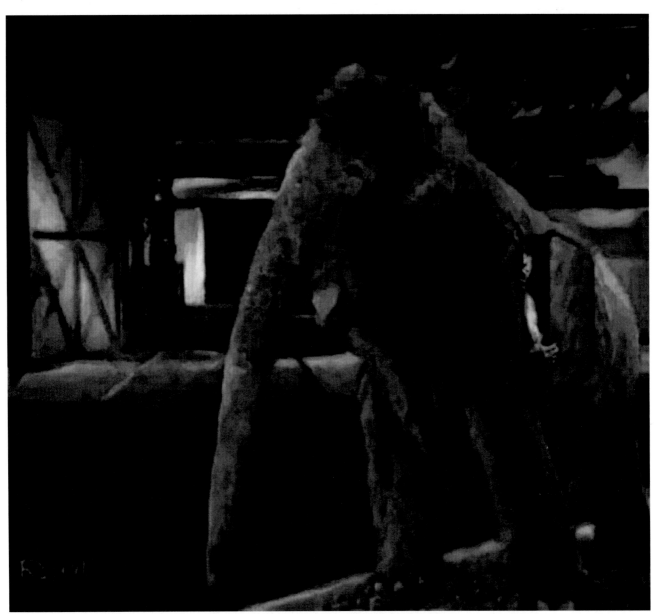

A BABY MAMMOTH

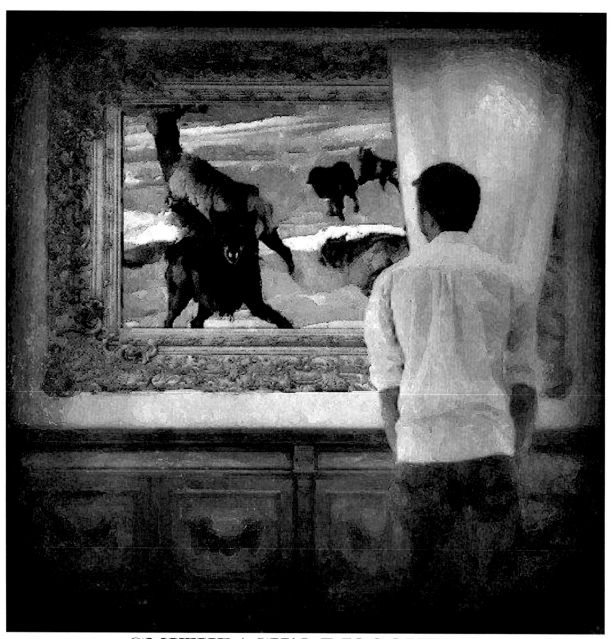

SMITHBACK'S DISCOVERY

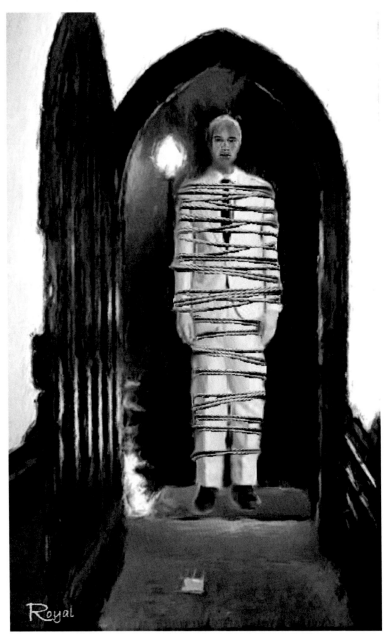

ALBAN'S ARRIVAL

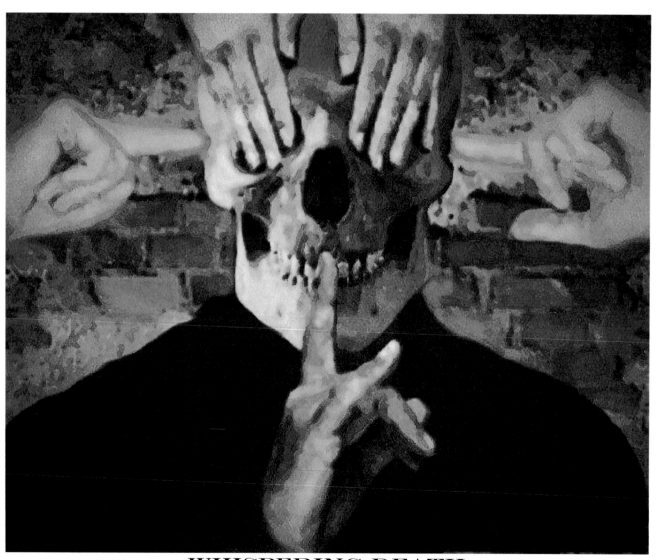

WHISPERING DEATH

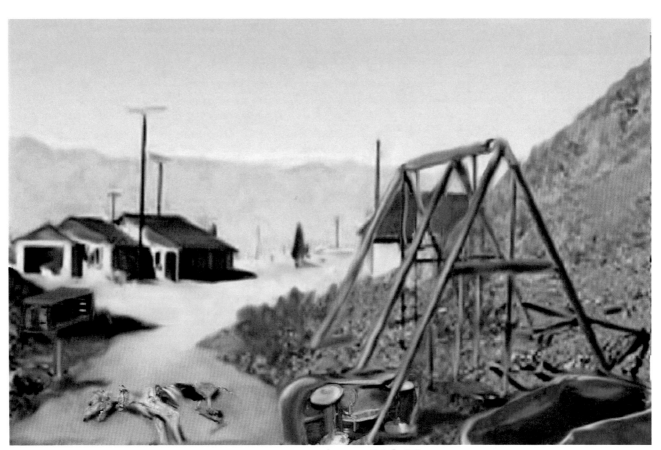

SALT & RUST

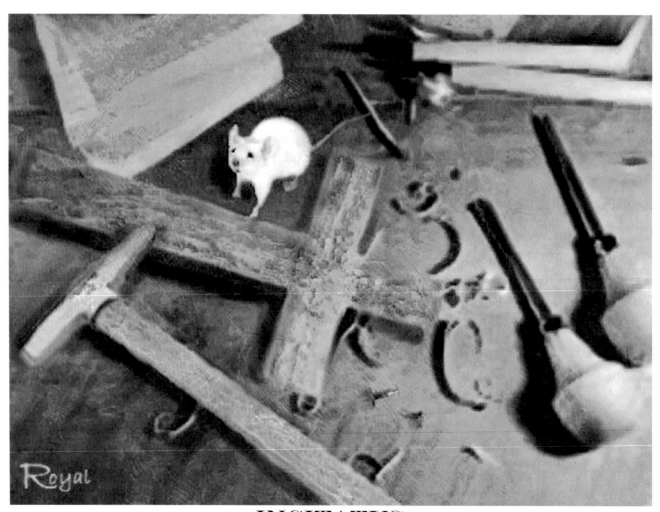

INCITATUS

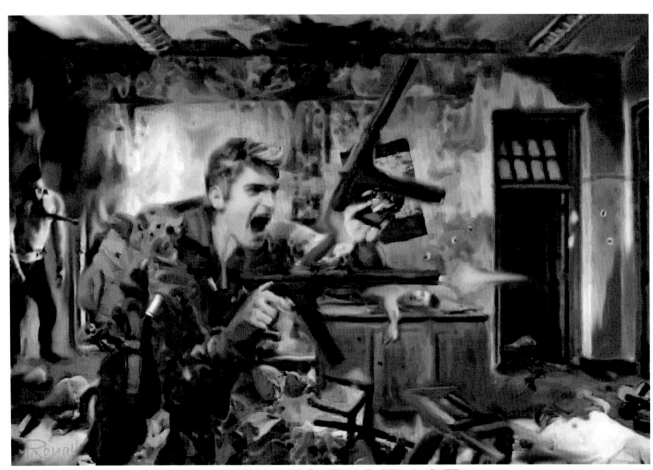

ALBAN'S RAMPAGE

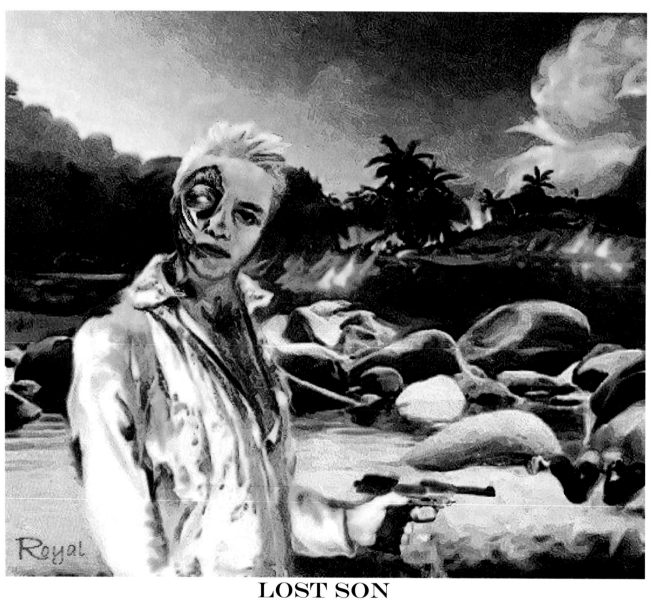

LOST SON

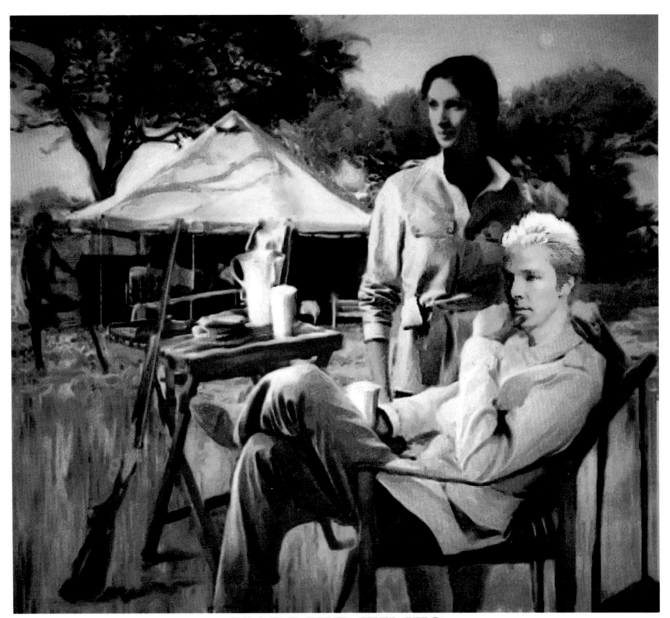

HAPPIER TIMES

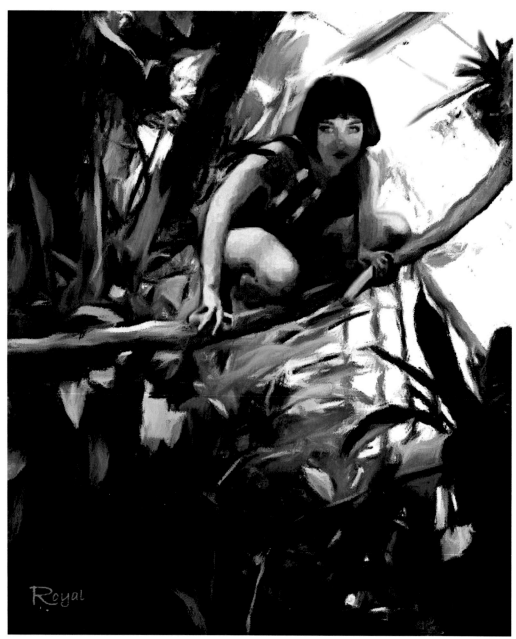

ACID TEST

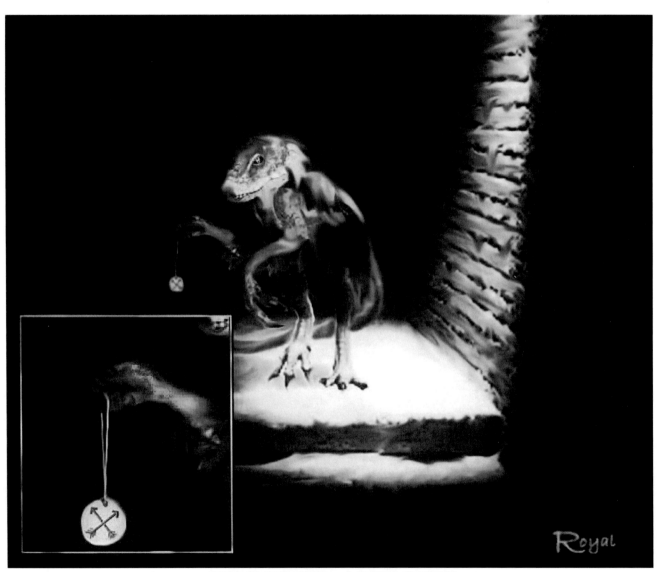

CROSSED ARROWS

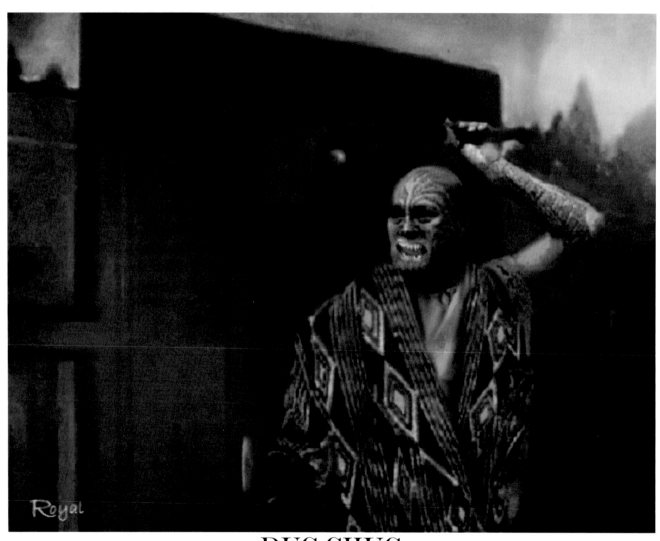

DUC CHUC

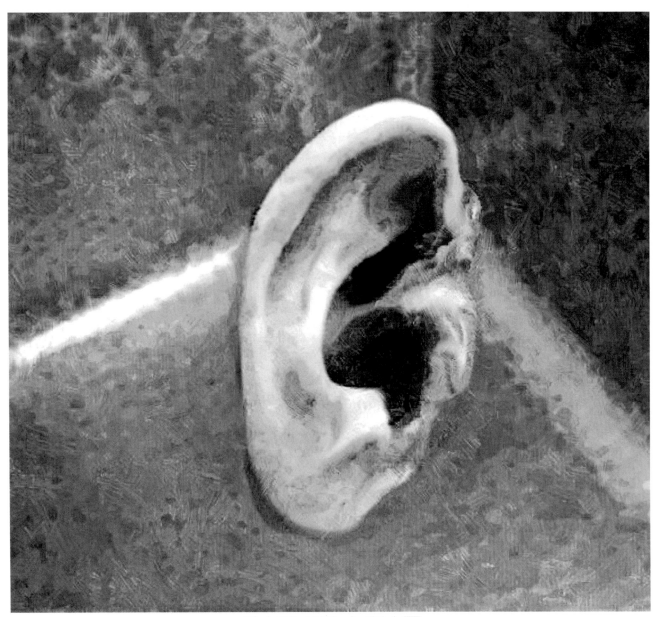

EAR IN A VAT

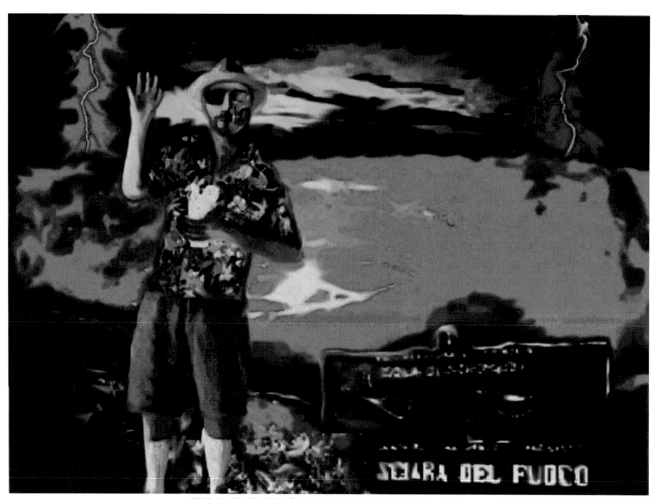

HALLUCINATIONS #1

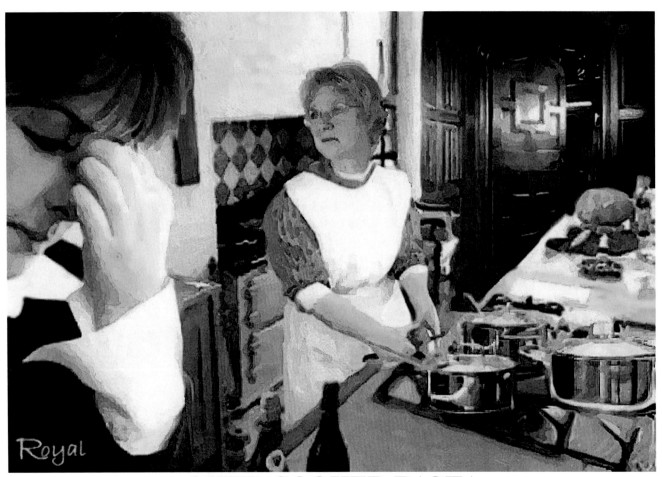

OVER-COOKED PASTA

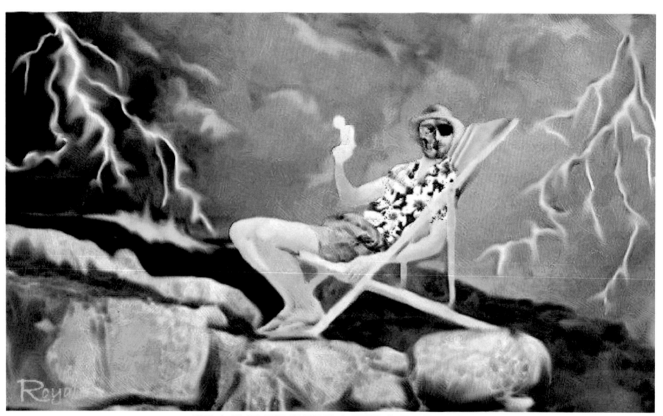

HALLUCINATIONS #2

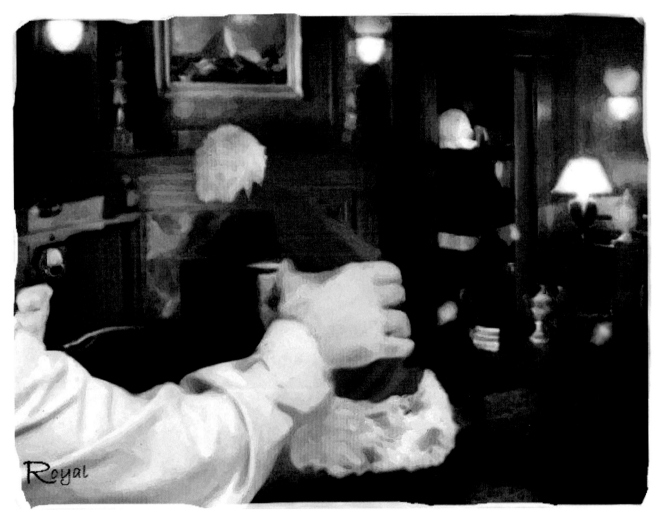

CHRISTMAS ON RIVERSIDE

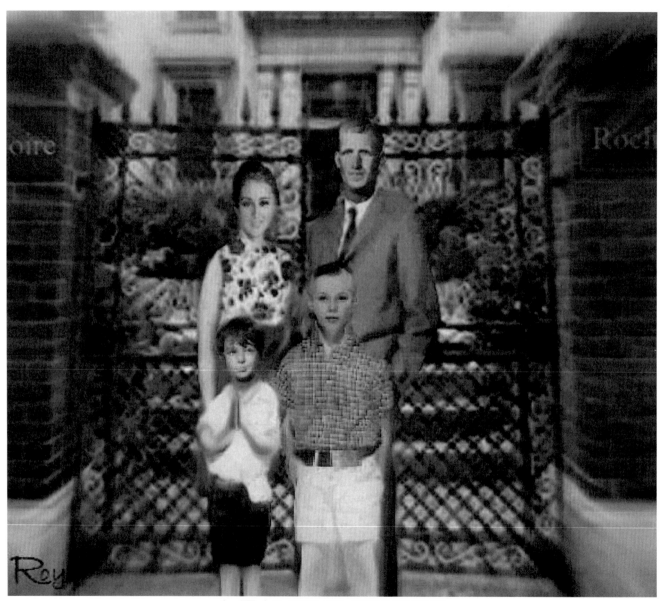

A FAMILY PHOTO

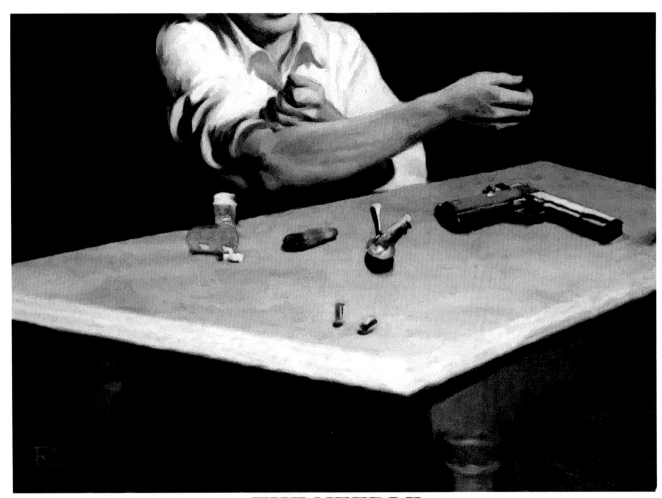

THE NEEDLE

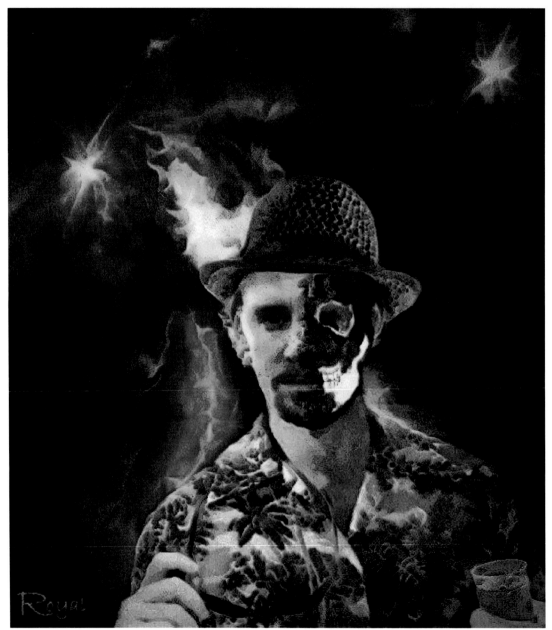

"AVE, FRATER!"

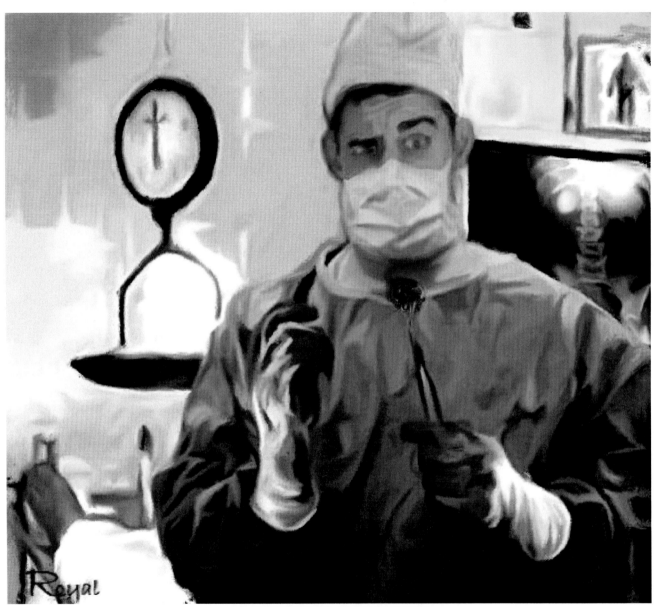

A BLUE STONE

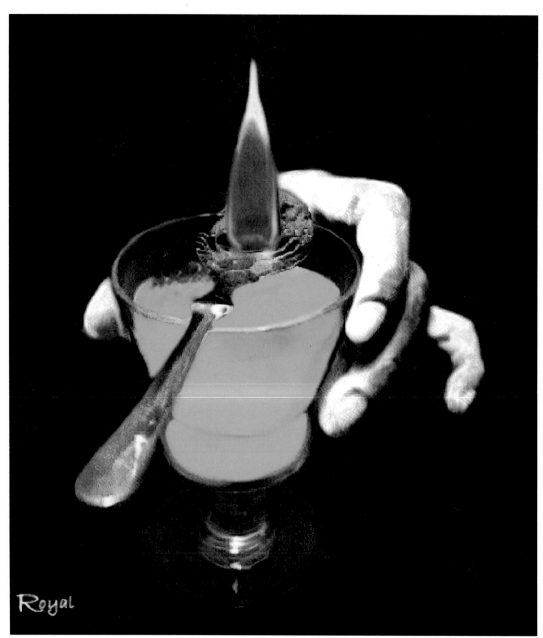

ABSINTHES

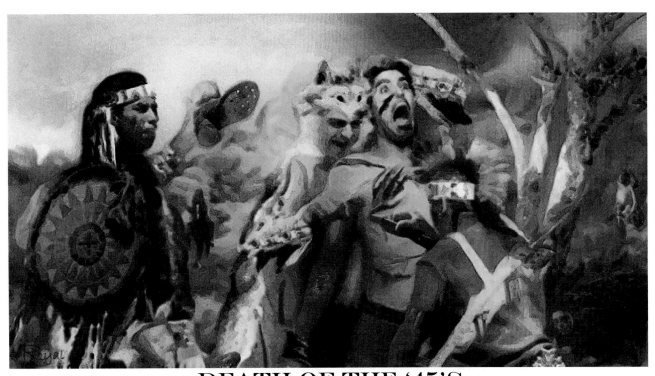

DEATH OF THE '45'S

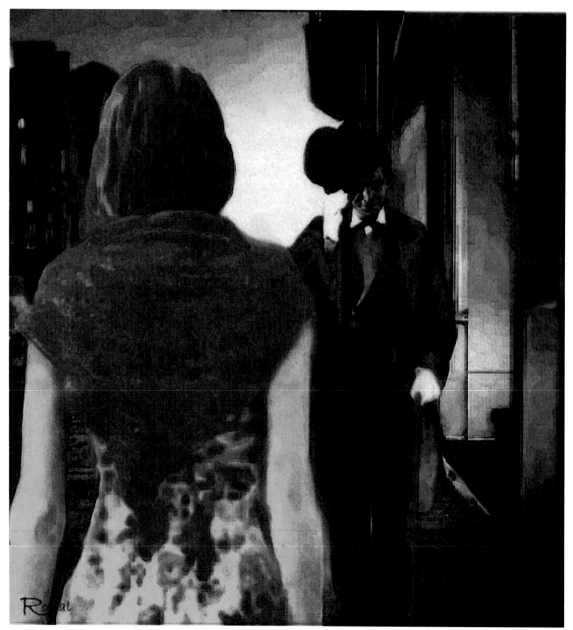

A TIP OF THE HAT

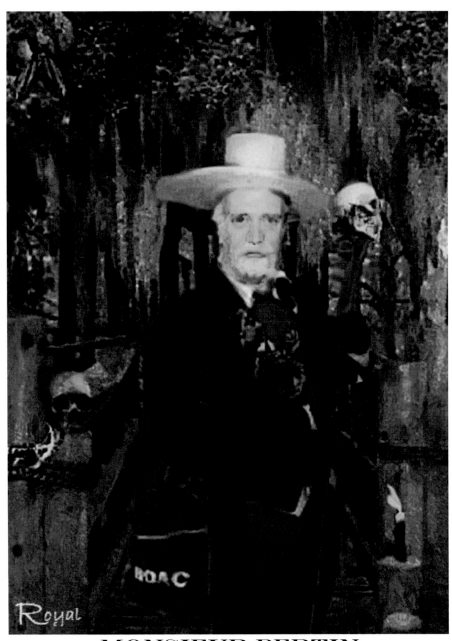

MONSIEUR BERTIN

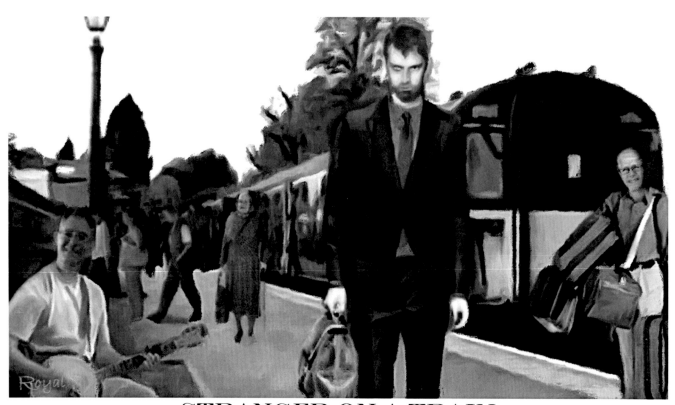

STRANGER ON A TRAIN

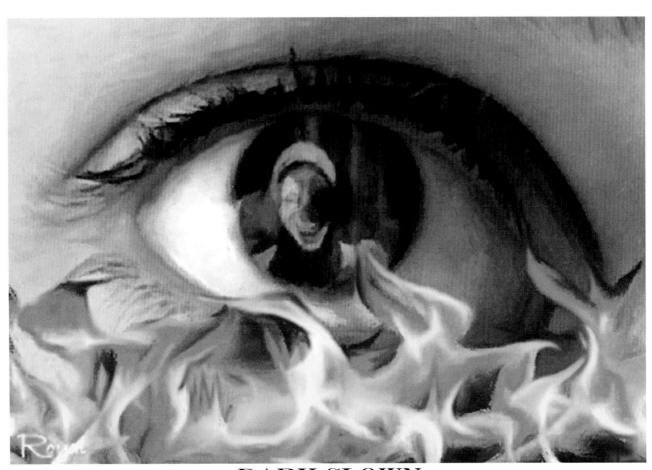

DARK CLOWN

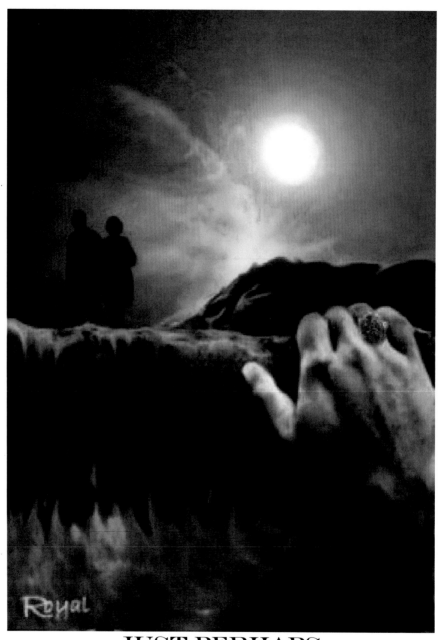

JUST PERHAPS

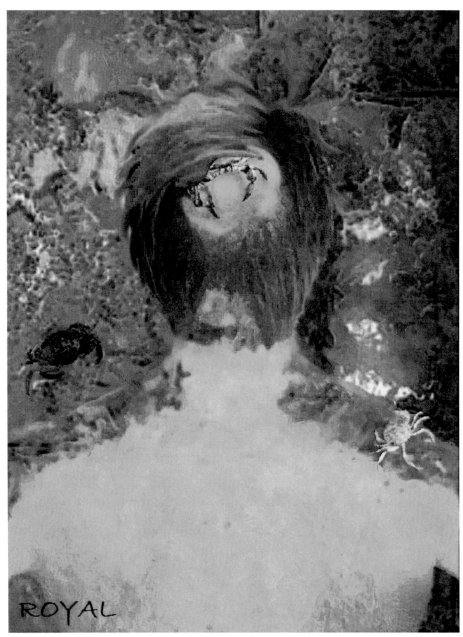

ROYAL

MUD FLATS

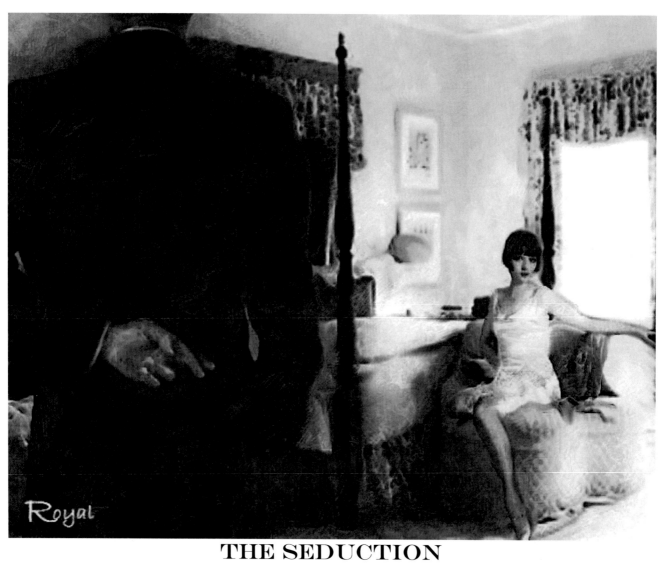

THE SEDUCTION

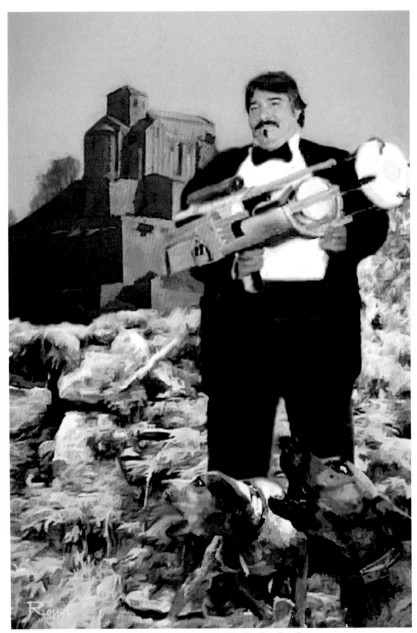

COUNT FOSCO

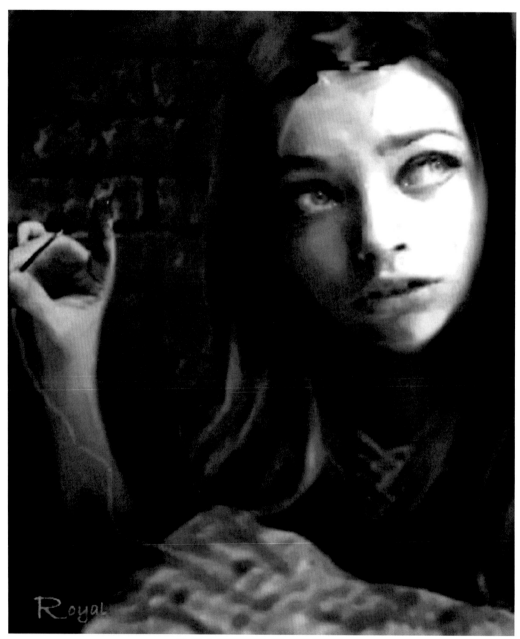

MARY'S INK

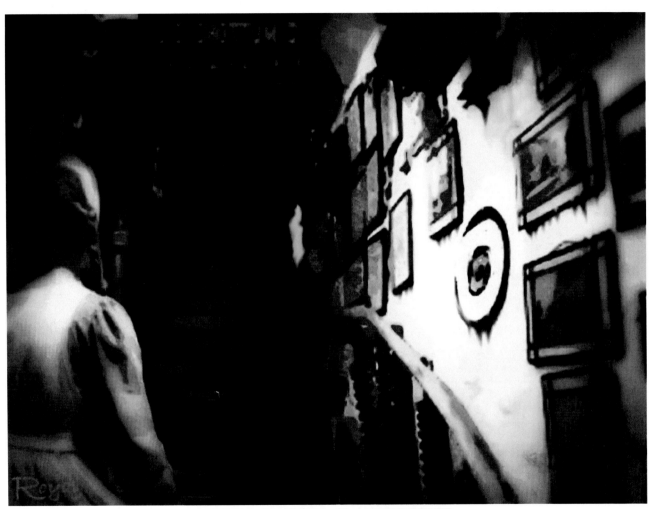

SHADOW CABINET

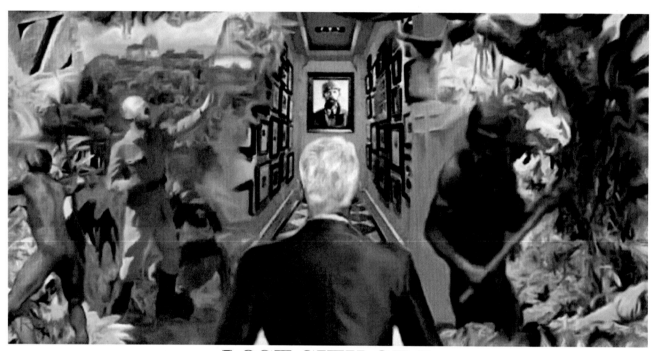

LOST CITY OF Z

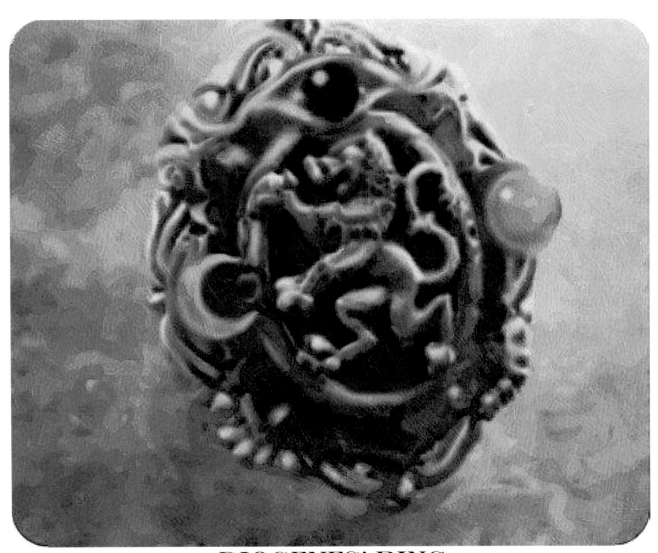

DIOGENES' RING

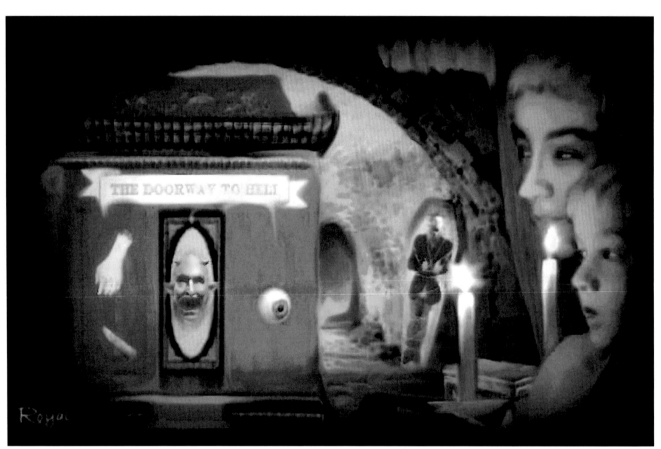

DOORWAY TO HELL

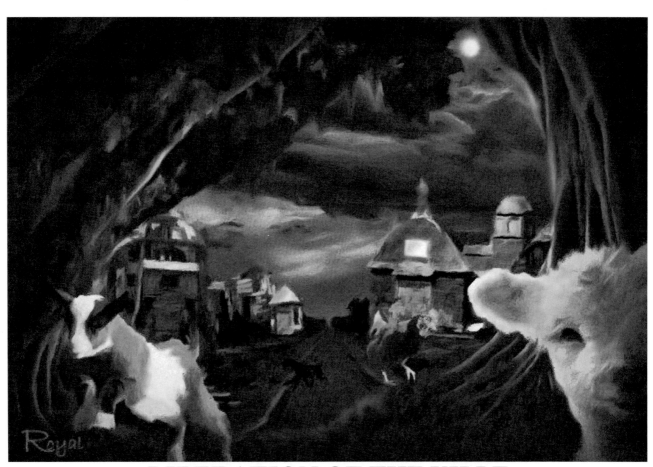

LIBERATION OF THE VILLE

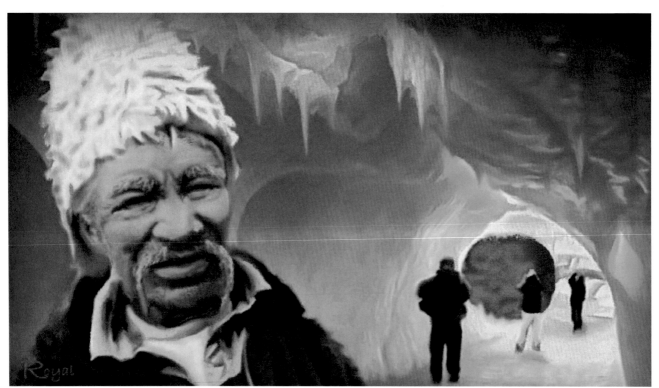

THE RED METEOR

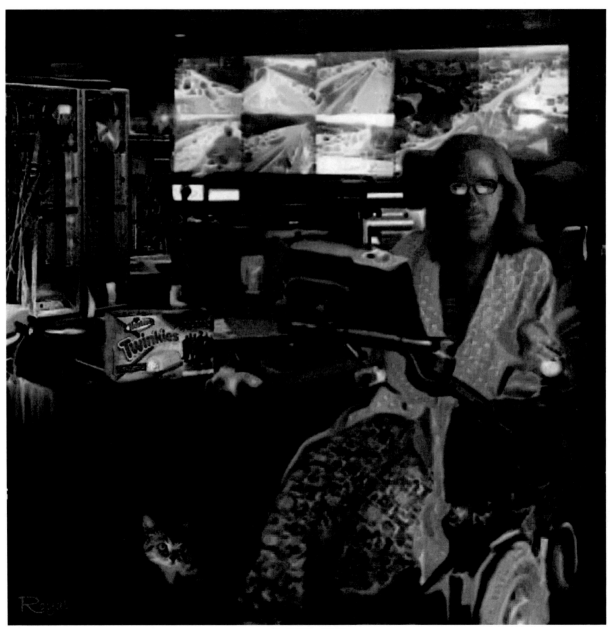

MIME

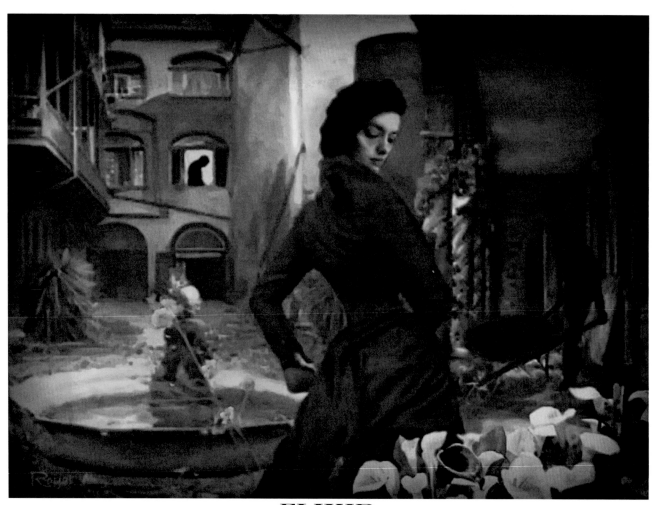

ELIXIR

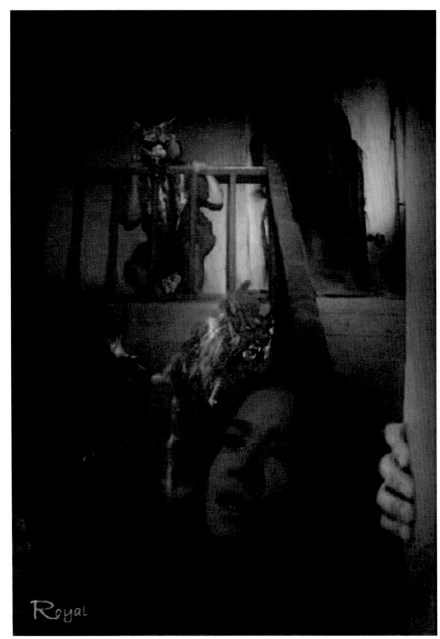

Royal

SKIN WALKERS

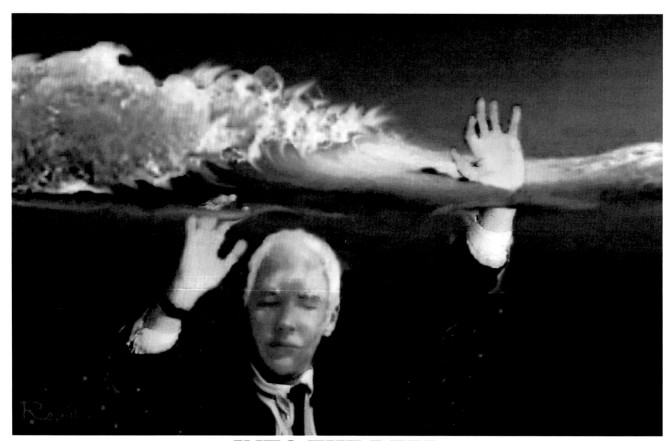

INTO THE DEEP

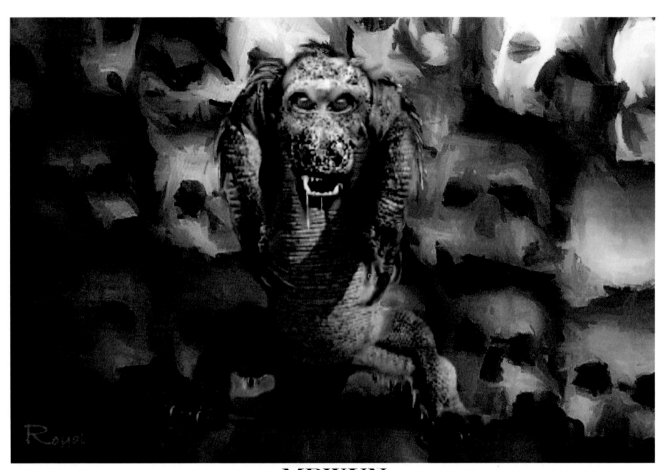

MBWUN

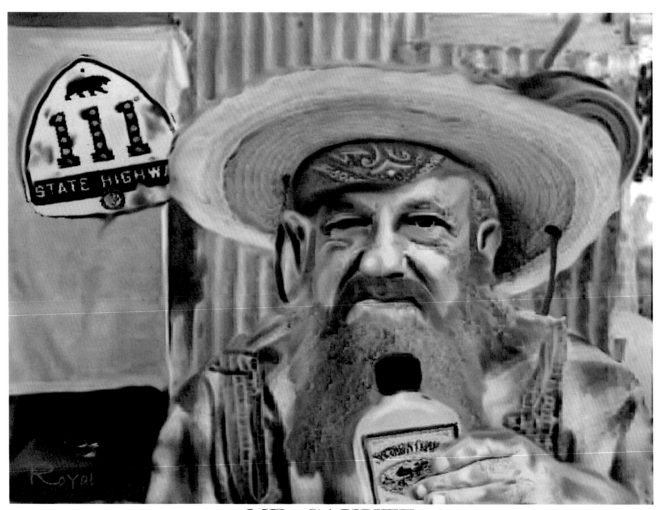

MR. CAYUTE

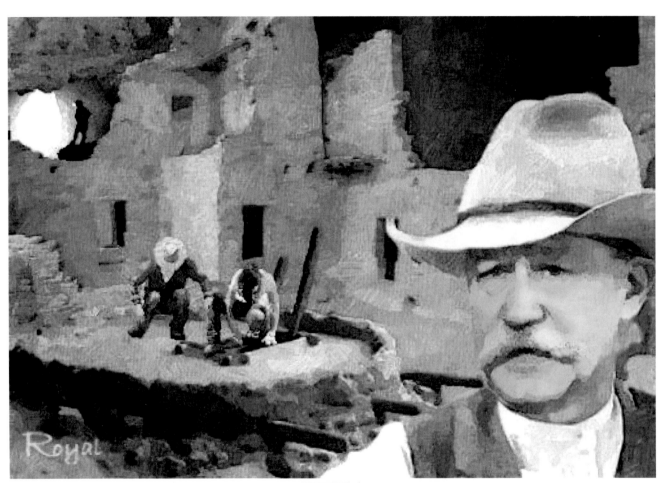

KIVA

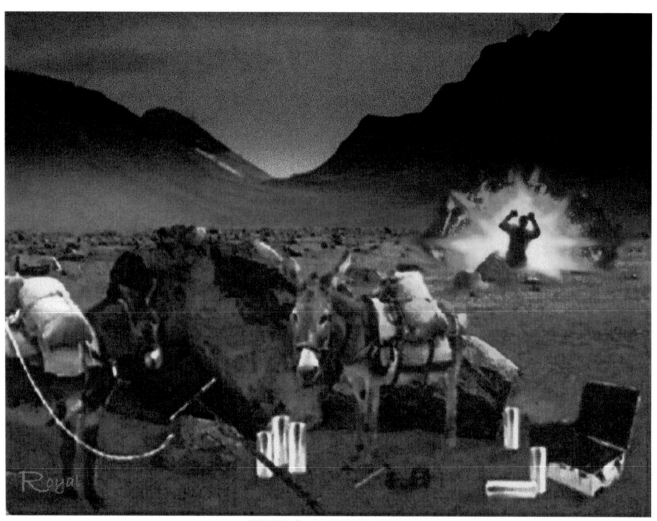

TWO MULES

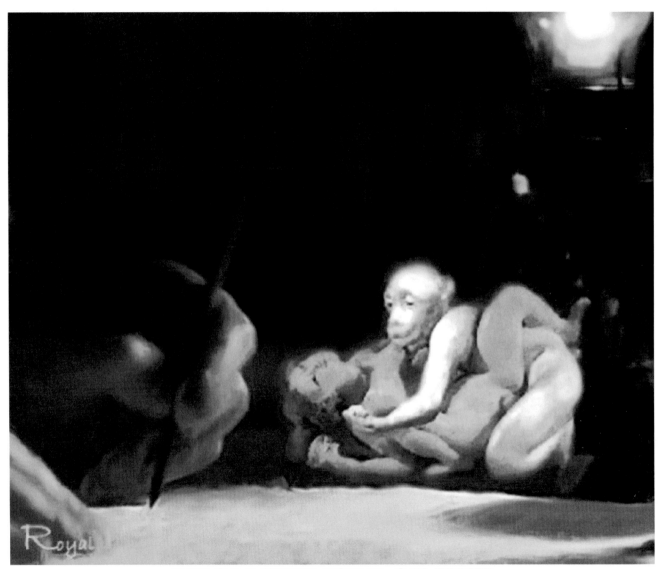

FROM THE ISLE OF KUT

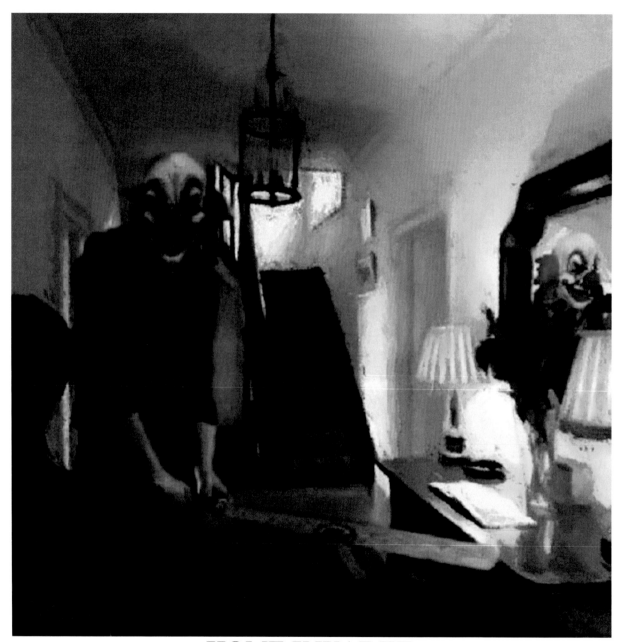

HOME INVADER

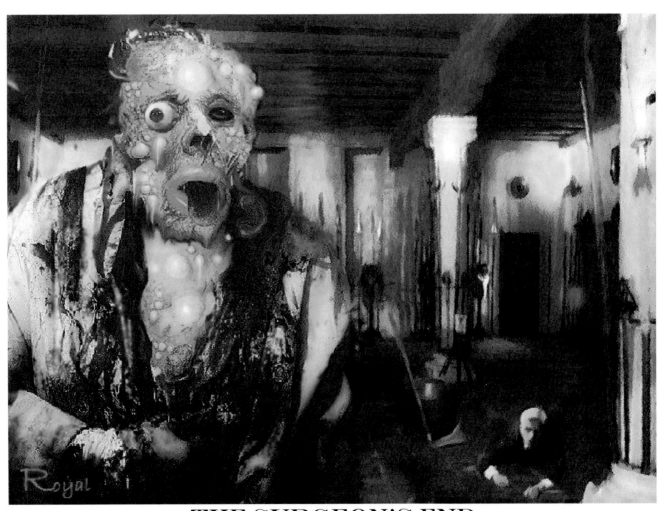

THE SURGEON'S END

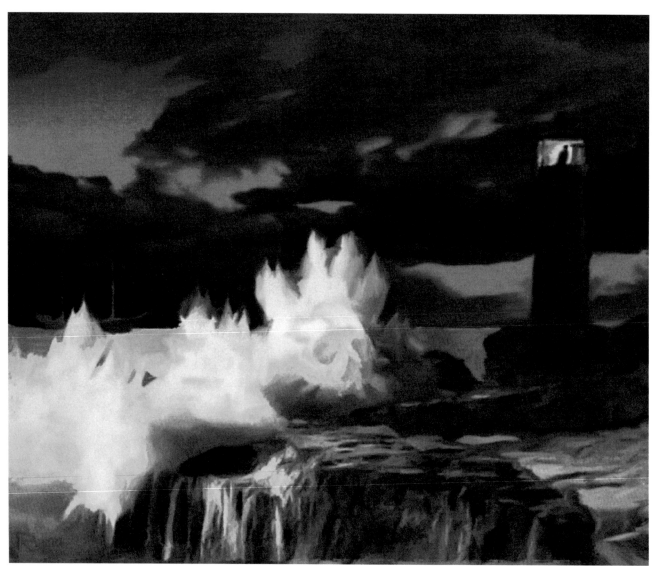

SKULL CRUSHER ROCK

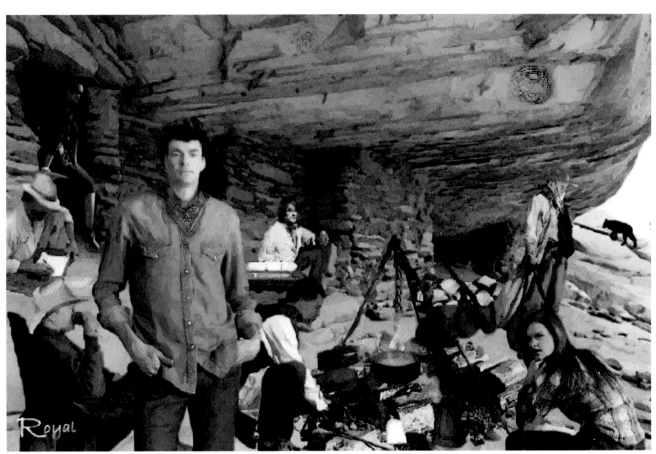

SMITHBACK AND CO.

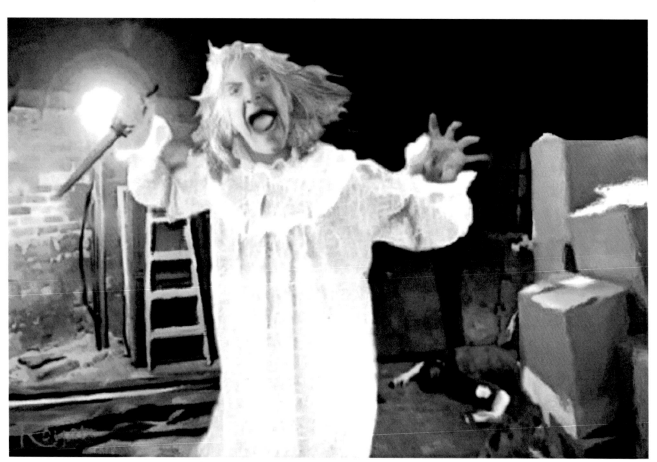

SWEET MRS. KRAUS

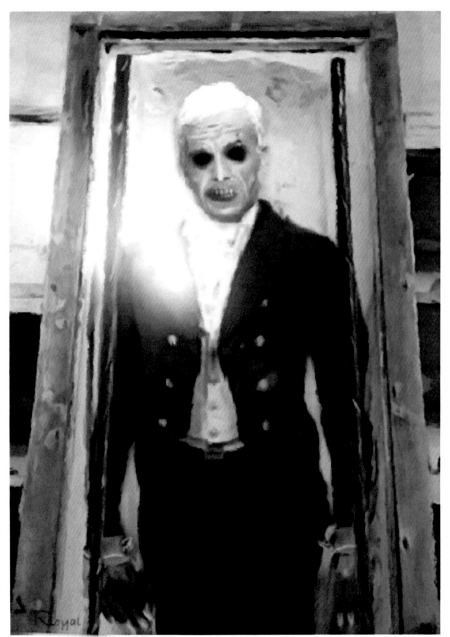

A RELATIVE

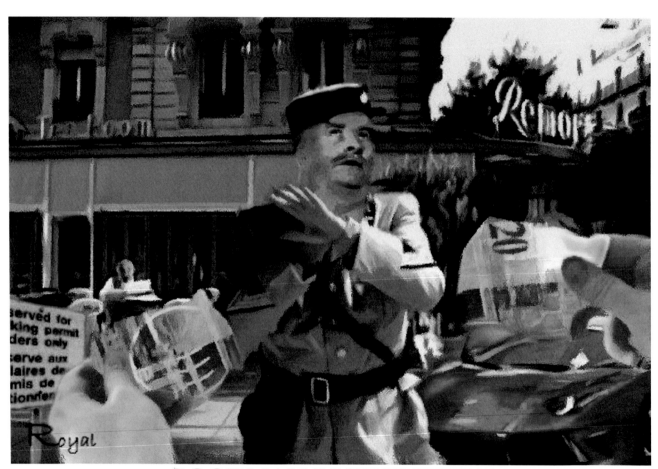

GOODMAN LICKSPITTLE

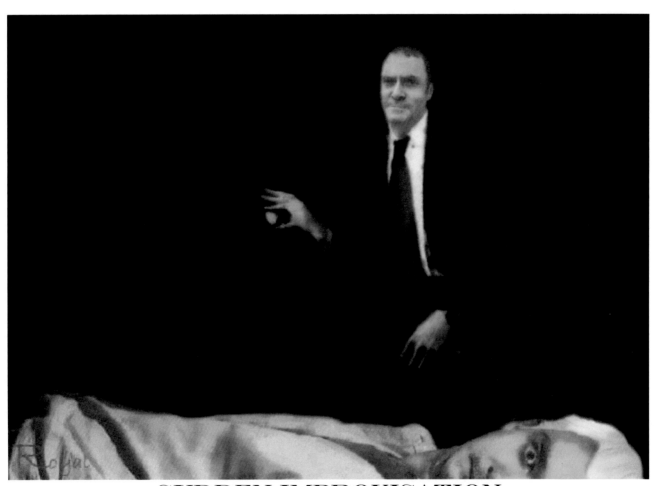

SUDDEN IMPROVISATION

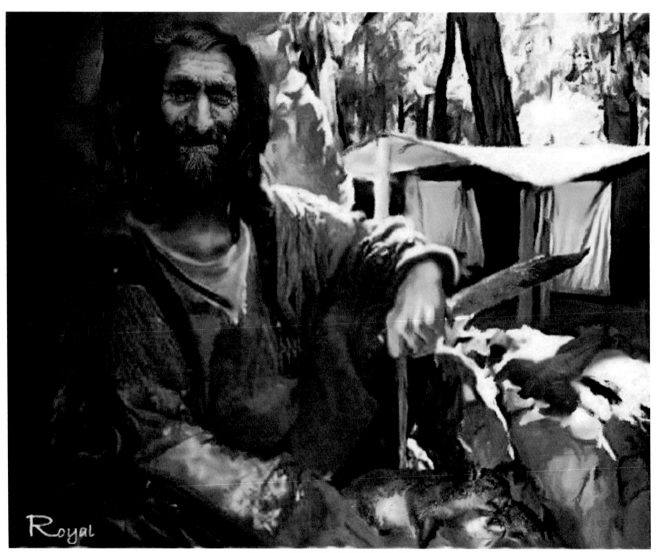

GASPARILLA

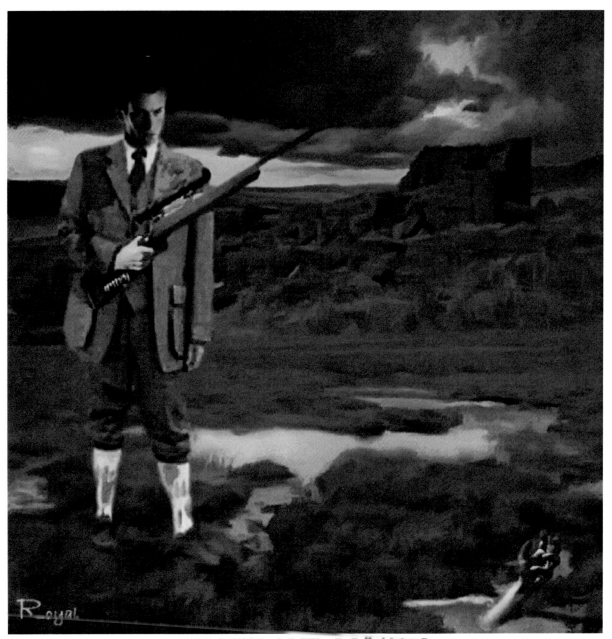

HIGHLAND MOORS

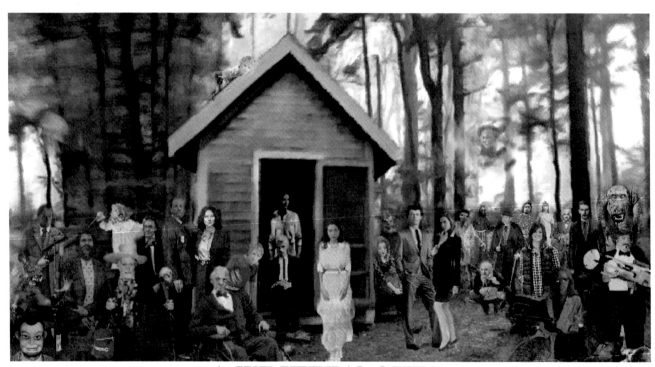

A WRITER'S SHED

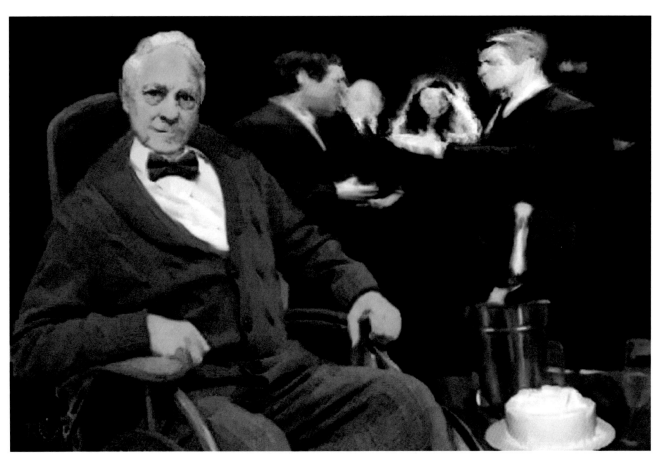

PROFESSOR FROCK

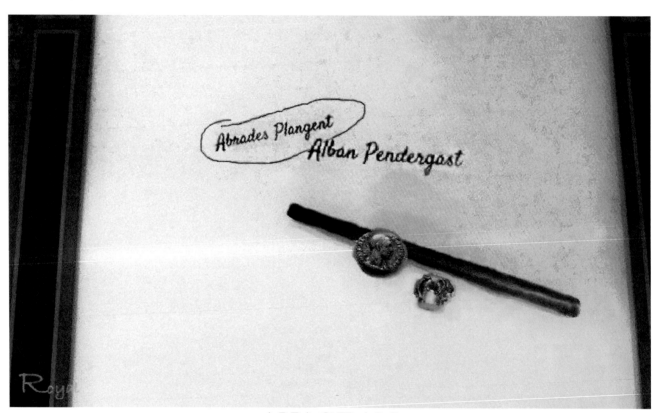

ANAGRAM

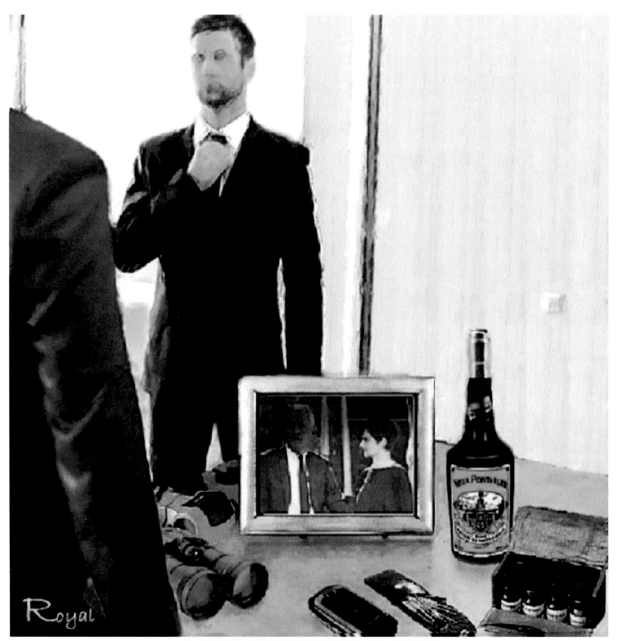

A BROTHER'S LOVE

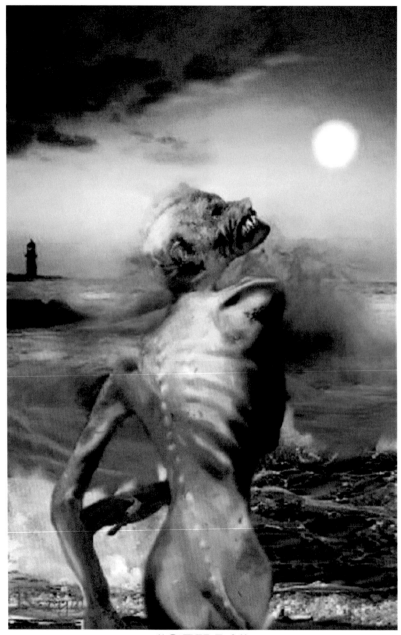

"SUN !"

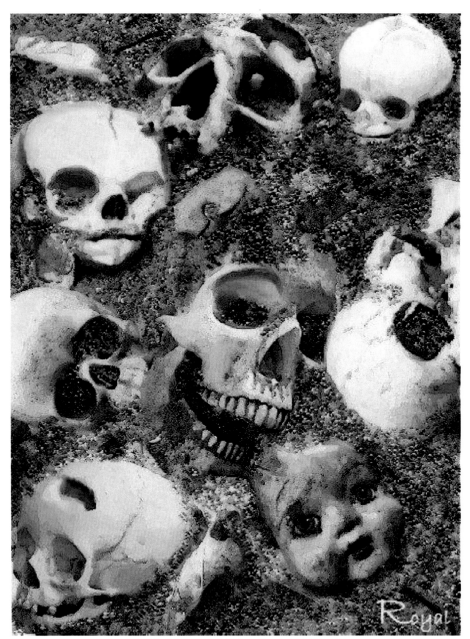

SHIFTED SANDS

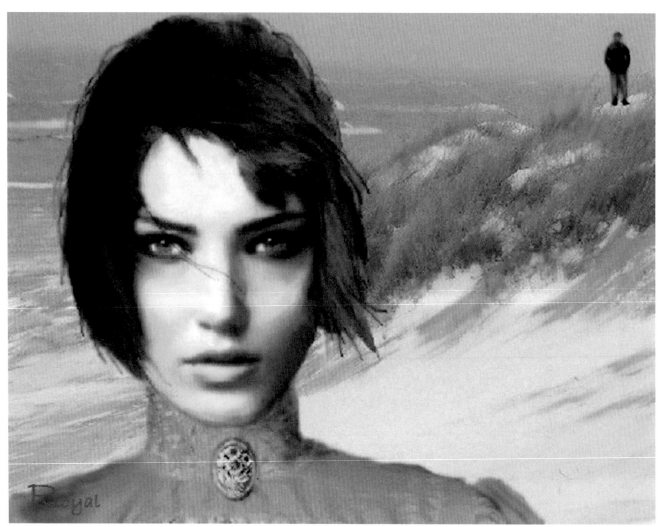

CONSTANCE

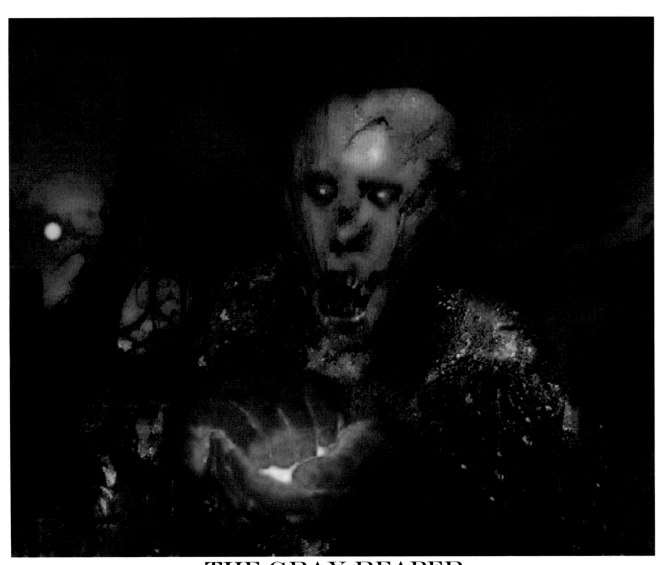

THE GRAY REAPER

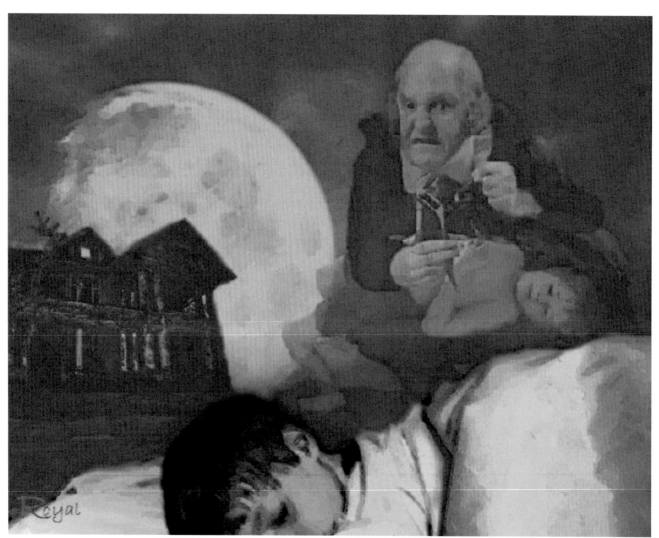

ENTER THE TOOTH FAIRY

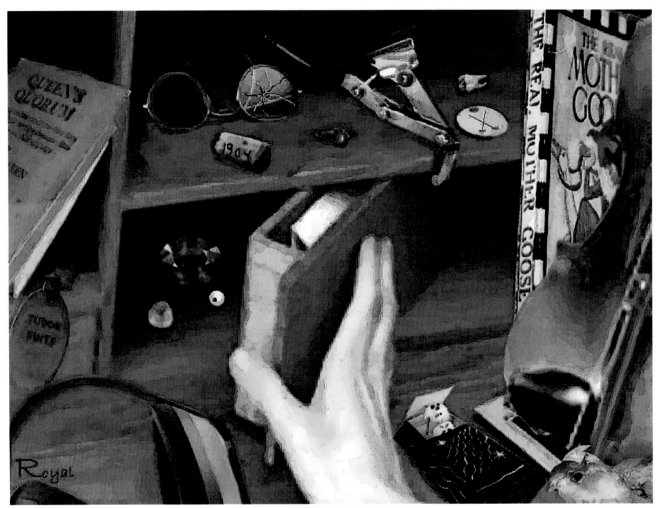

SOUVENIRS

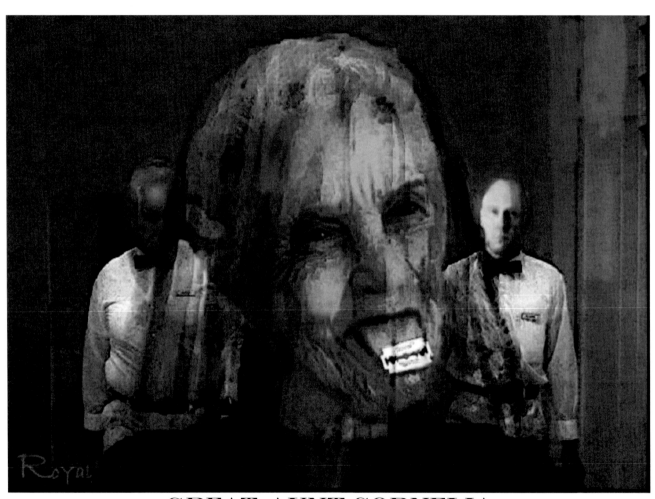

GREAT-AUNT CORNELIA

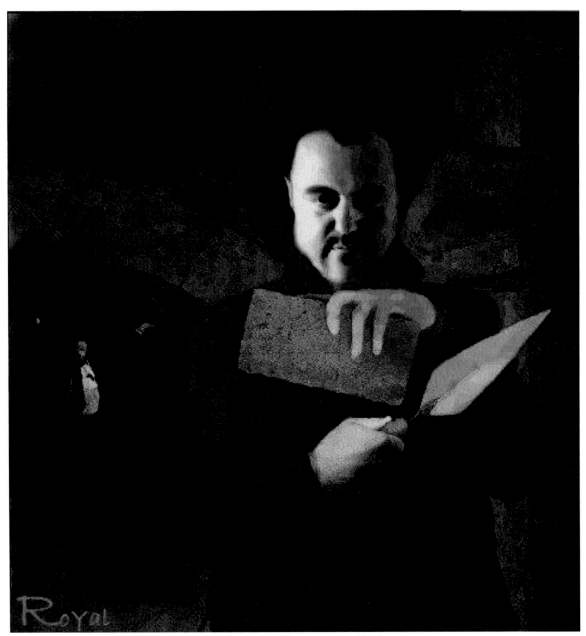

BRICK BY BRICK

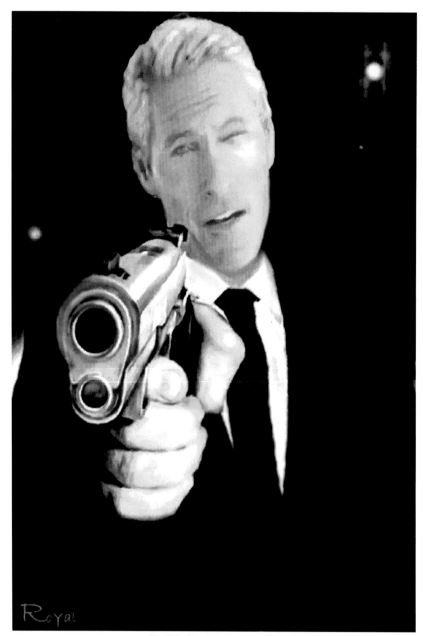

LES BAER

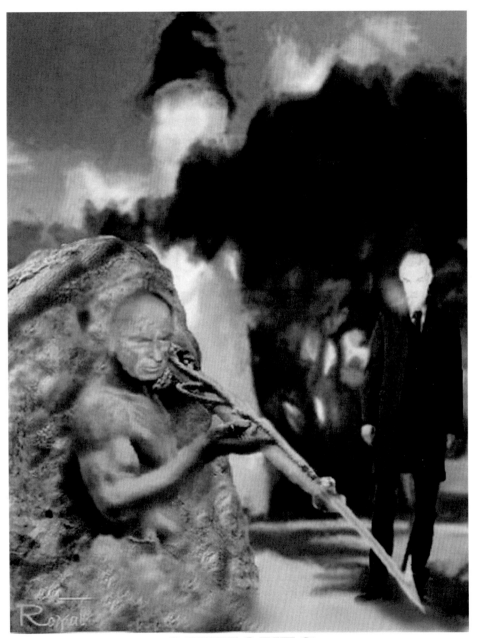

QUEEQUEG

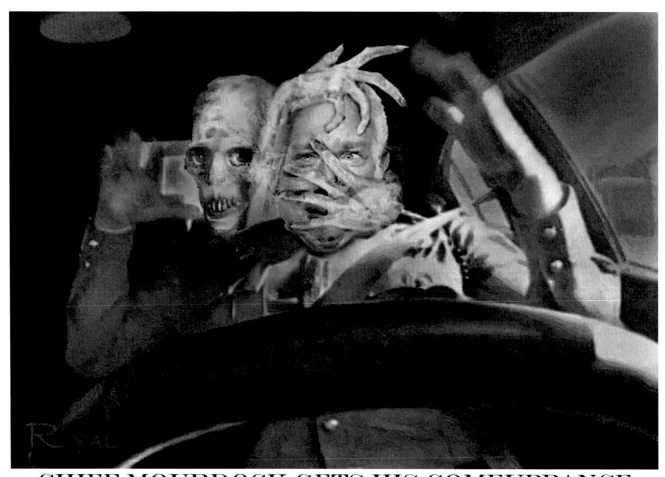

CHIEF MOURDOCK GETS HIS COMEUPPANCE

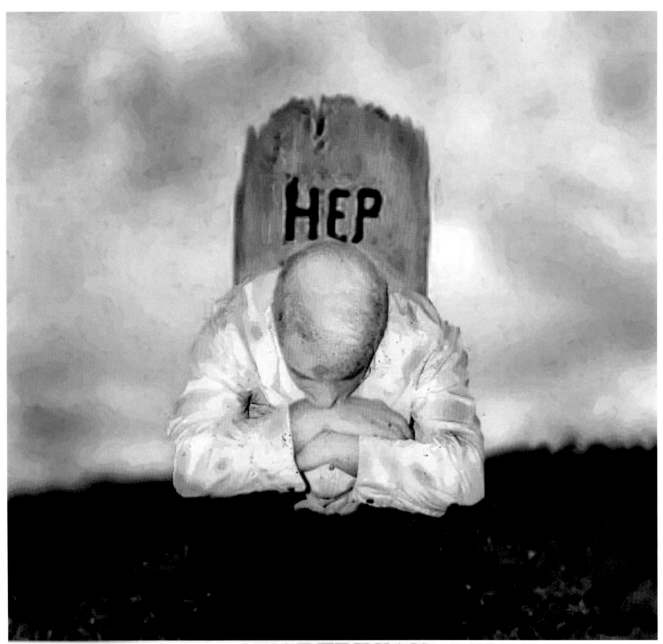

HEARTBREAK

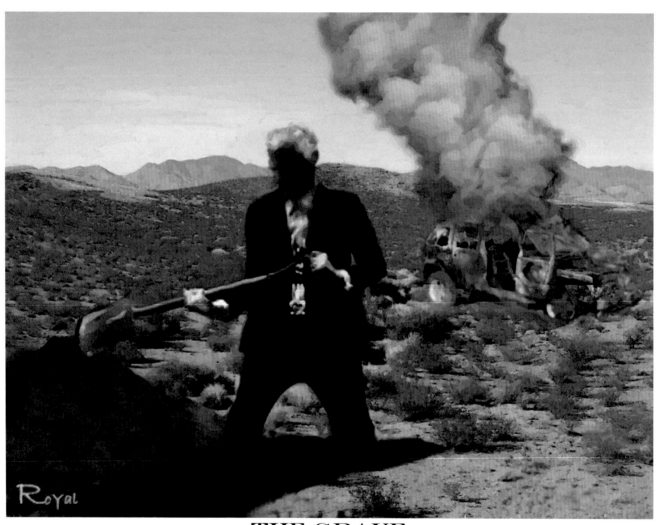

THE GRAVE

FLÁVIA

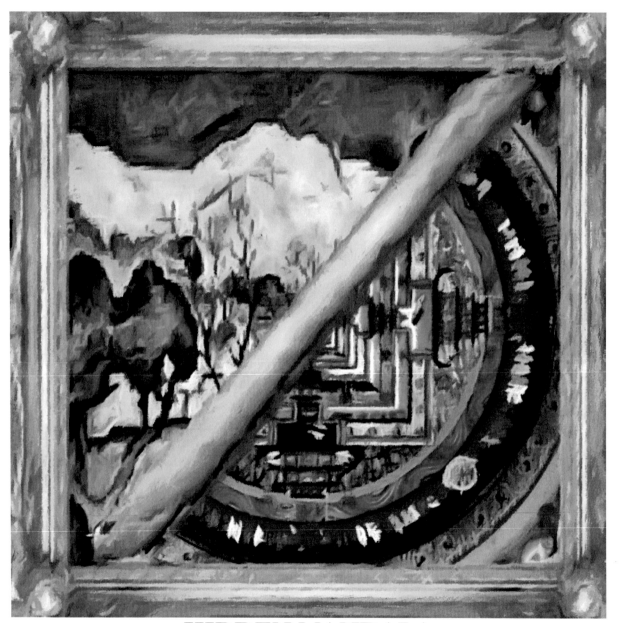

HIDDEN MANDALA

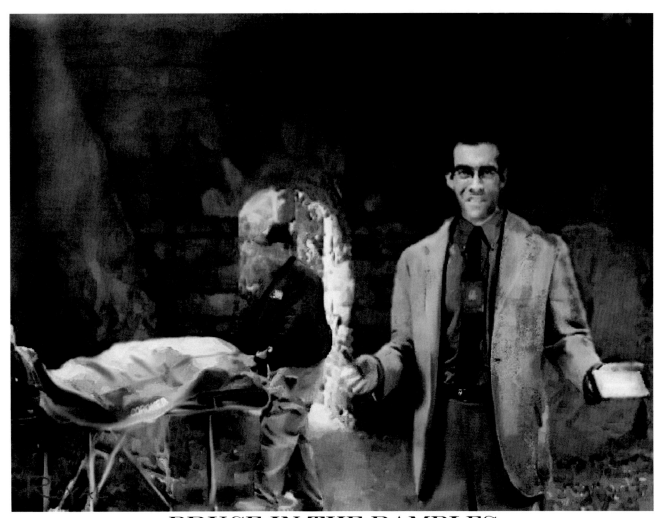

BRYCE IN THE RAMBLES

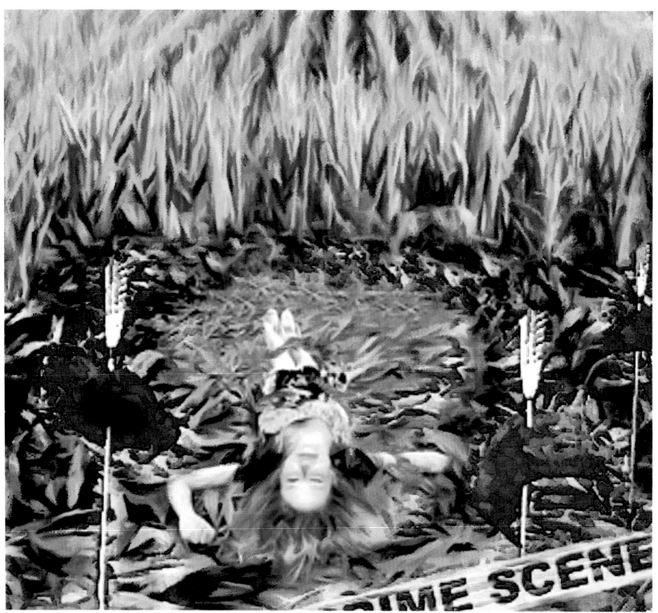

A STILL LIFE

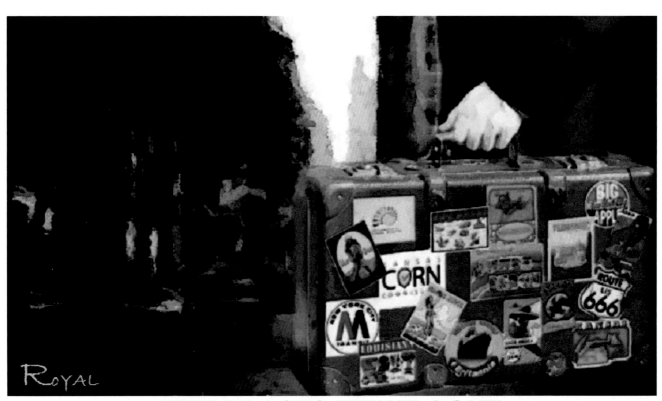

THE PLACES WE'VE GONE

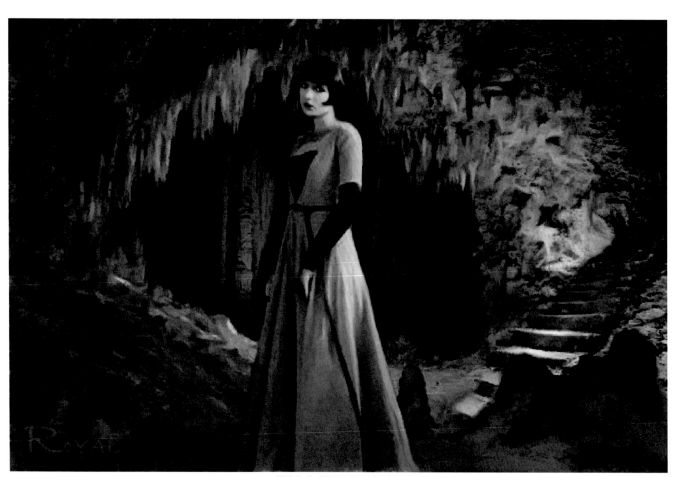

WAITING

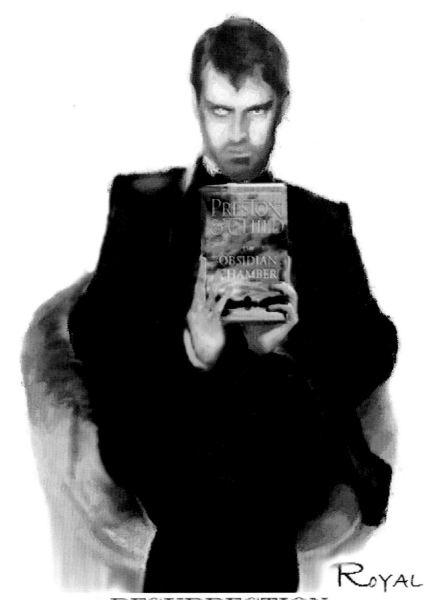

RESURRECTION

ROYAL

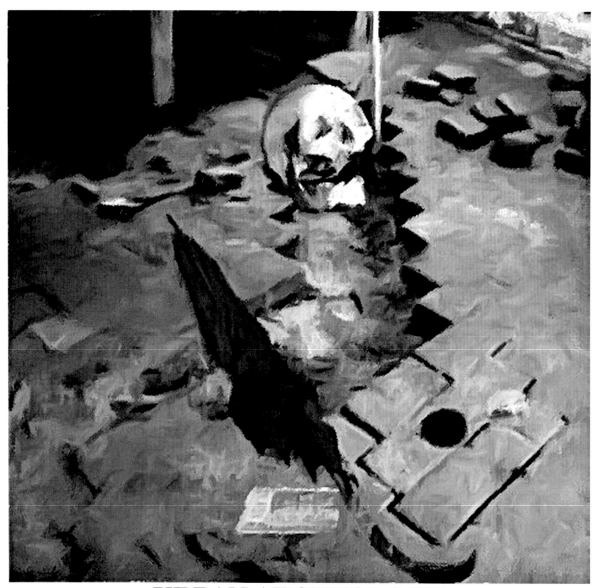

URBAN ARCHEOLOGY

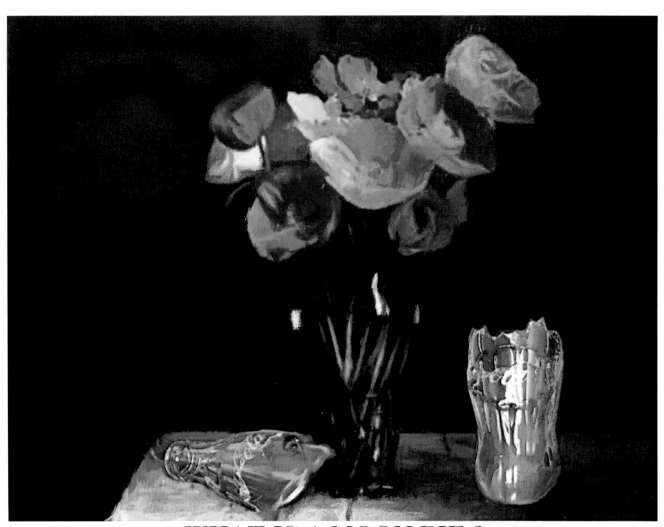

WHAT IS A MOON PIE ?

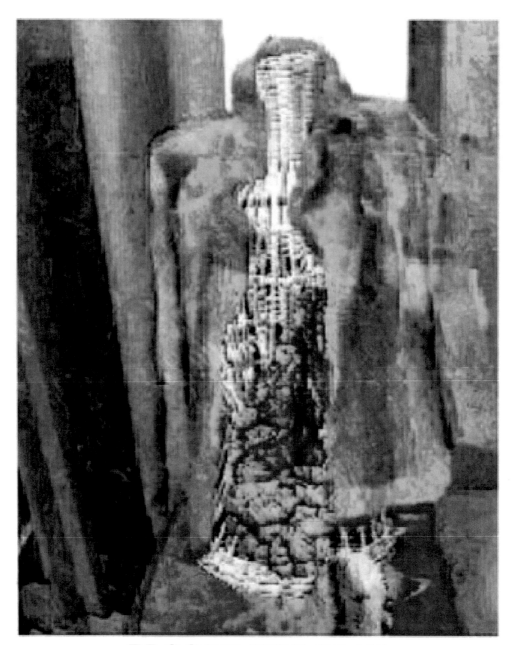

BLOODY FUR COAT

THE CASK OF AMONTILLADO

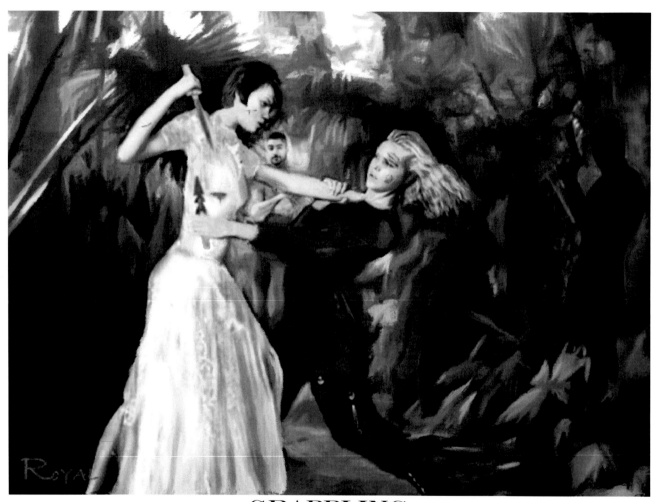

GRAPPLING

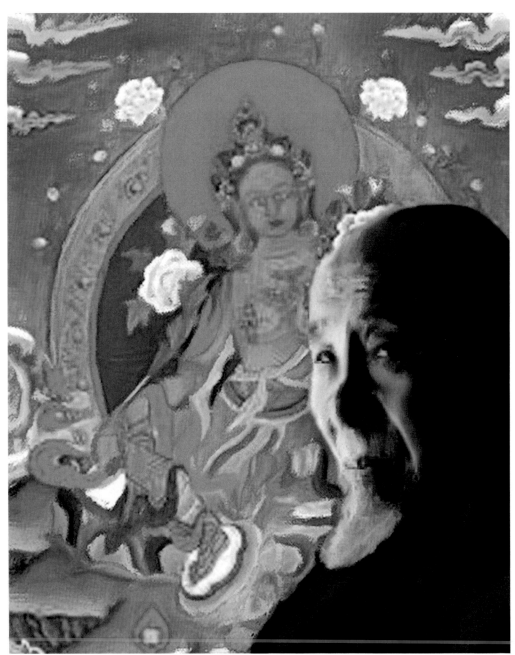

GREEN TANKA

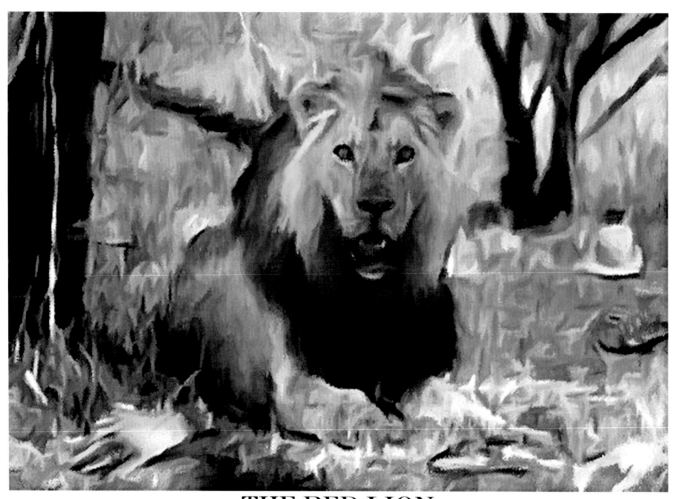

THE RED LION

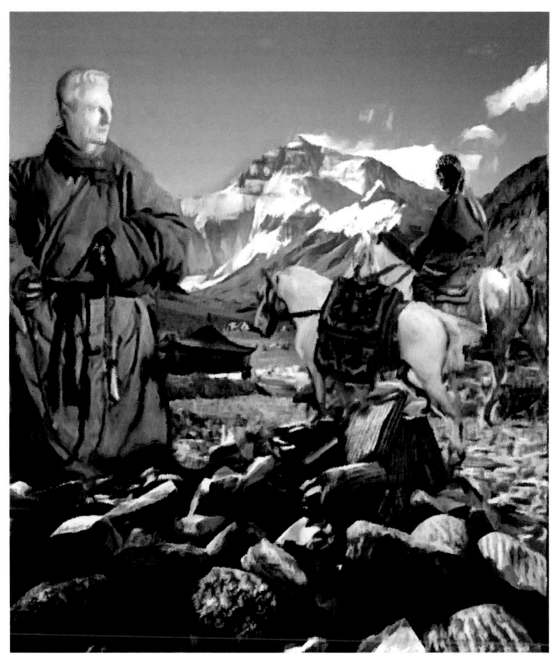

PRAYER STONES

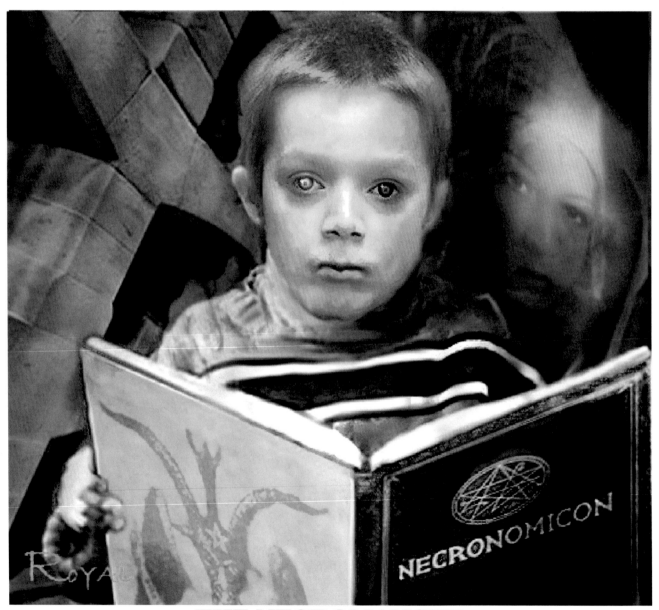

THE NECROMANCER

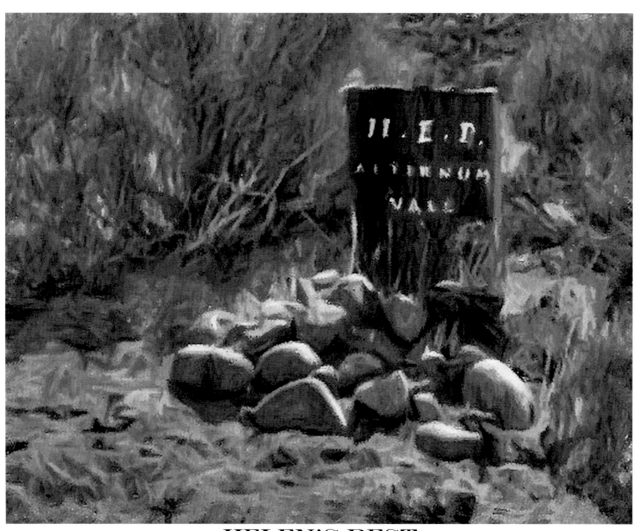

HELEN'S REST

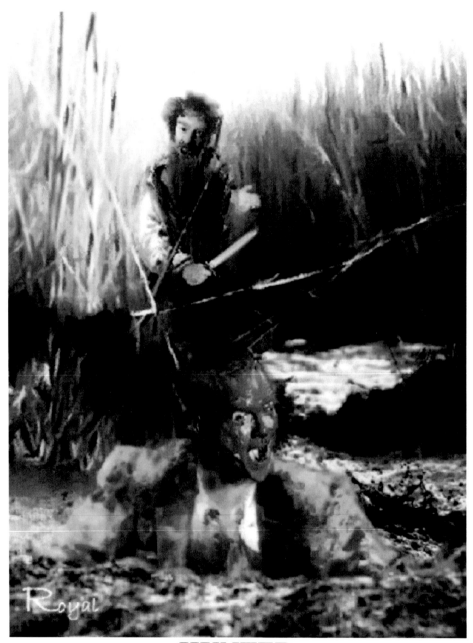

HUNTED

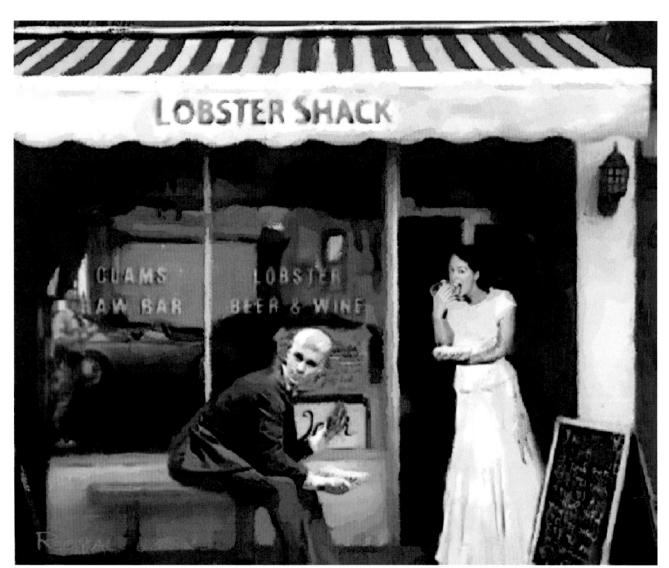

HOW DOES ONE EAT THIS?

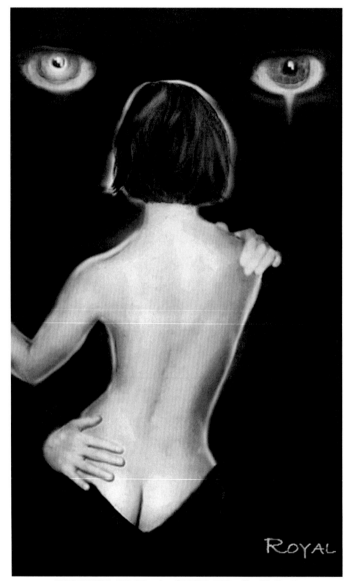

THE BLACK ROOM

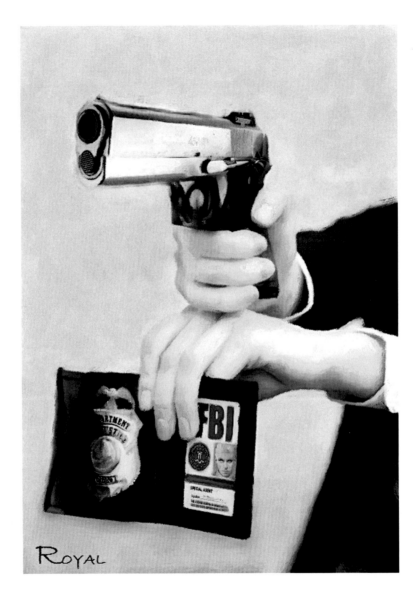

Royal

STAND VERY STILL

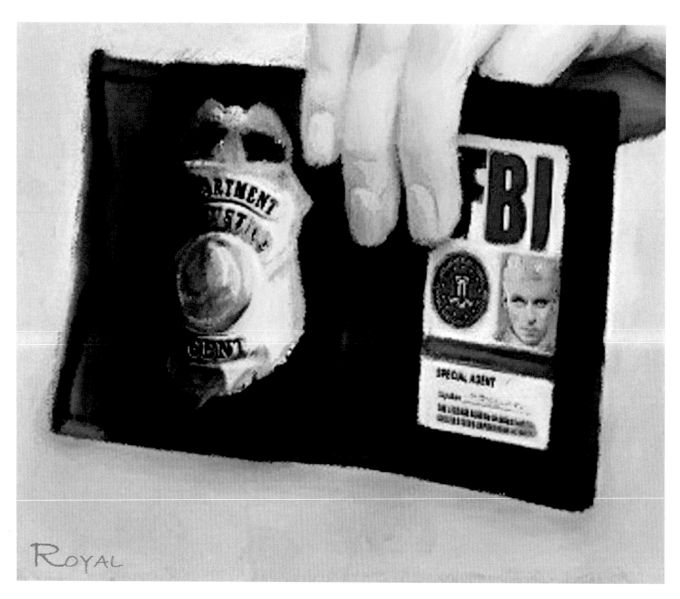

AND YOU ARE?

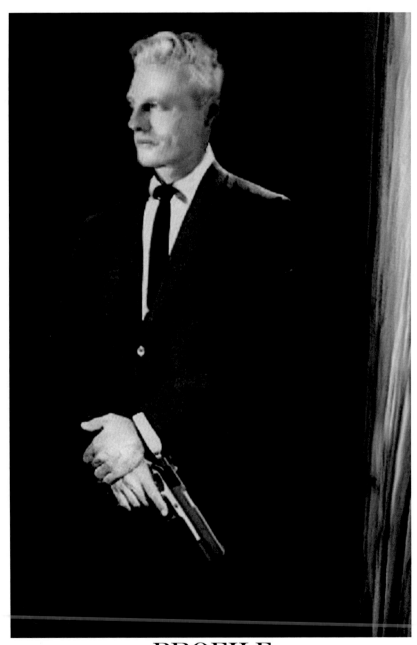

PROFILE

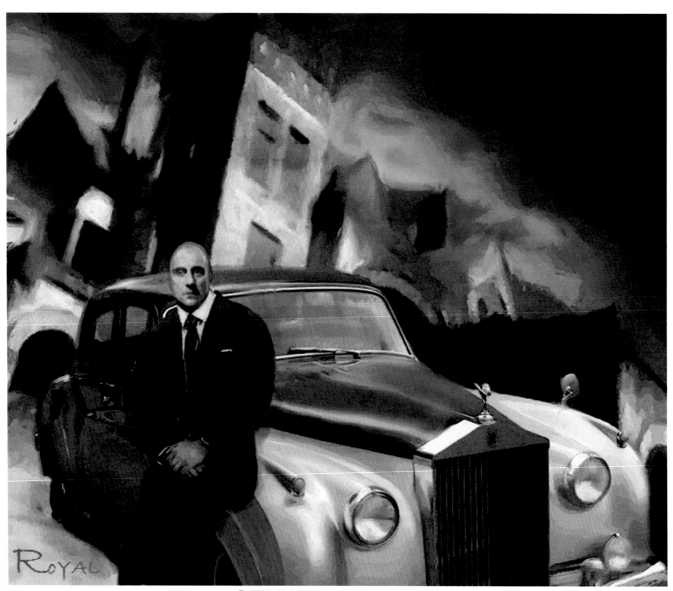

SILVER WRATH

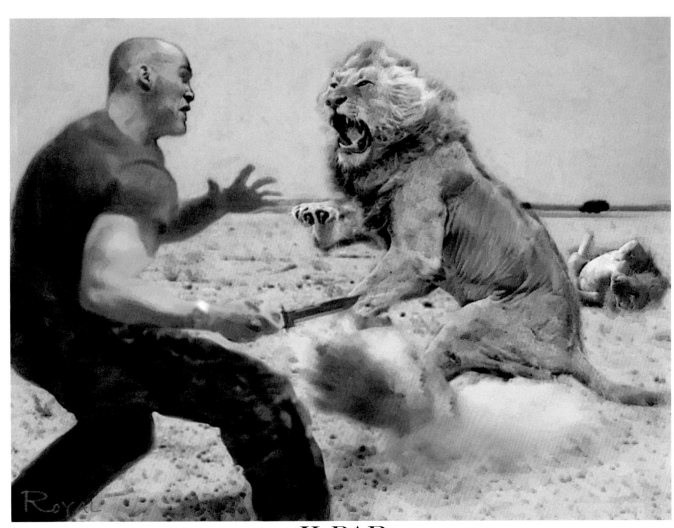

K-BAR

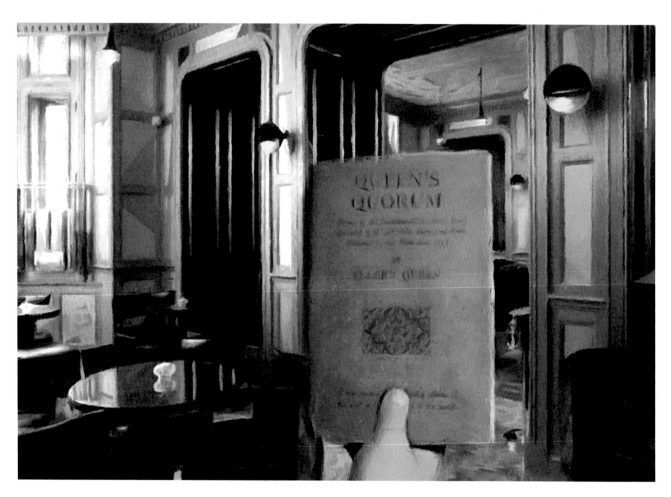

QUEEN'S QUORUM

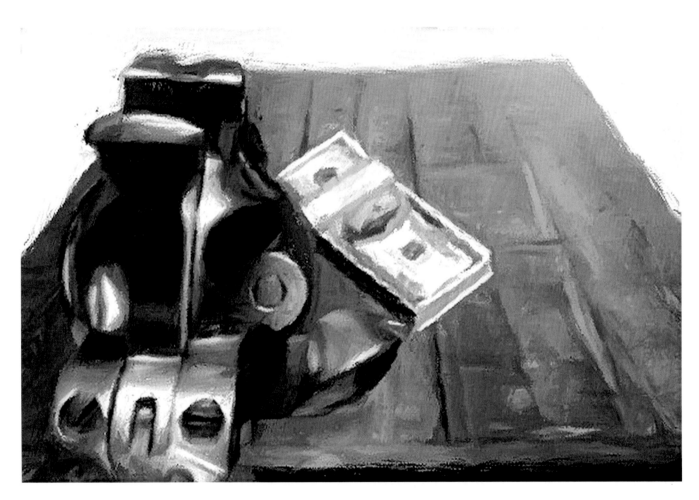

ROULETTE

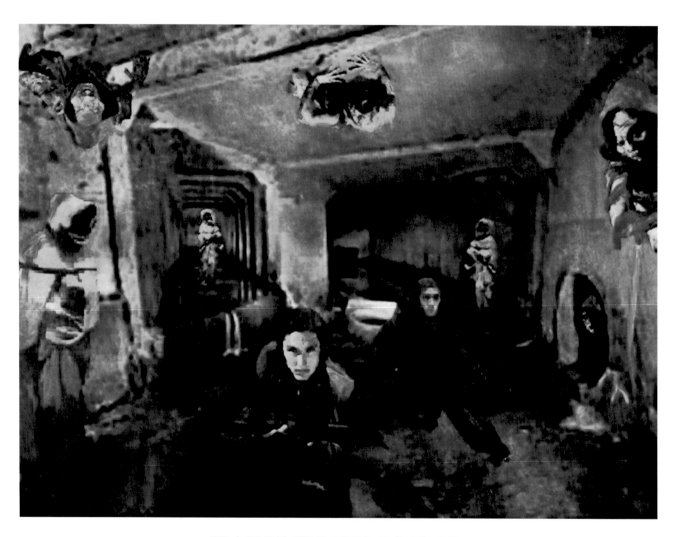

EARN YOUR M.R.E.

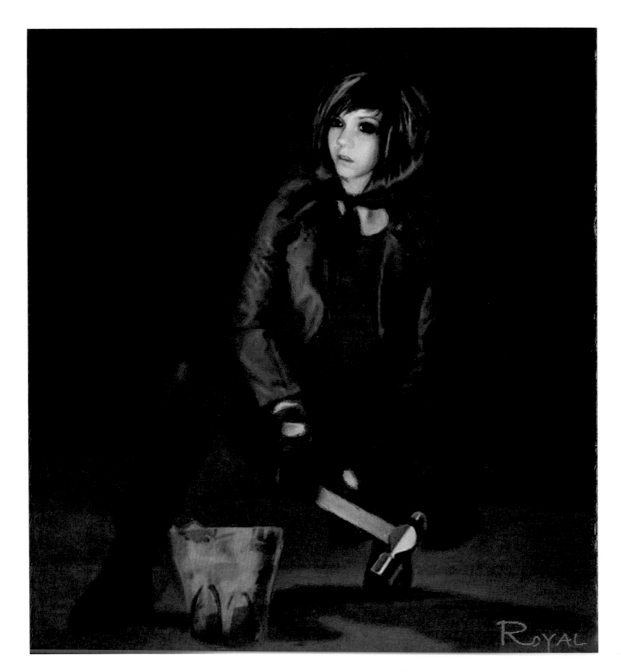

DETERMINATION

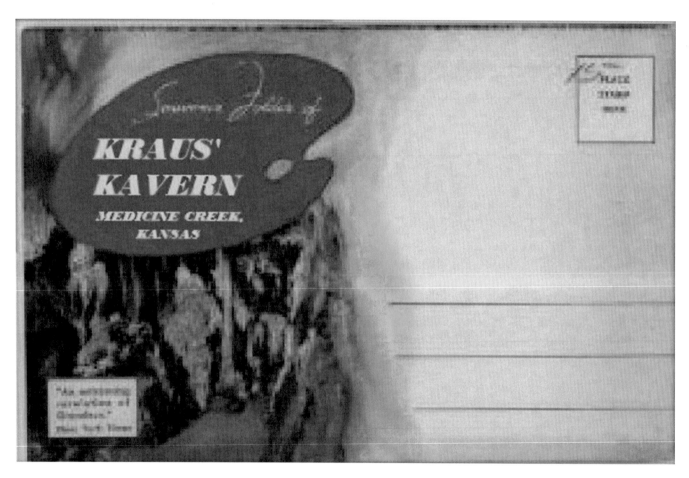

GREETINGS FROM MEDICINE CREEK

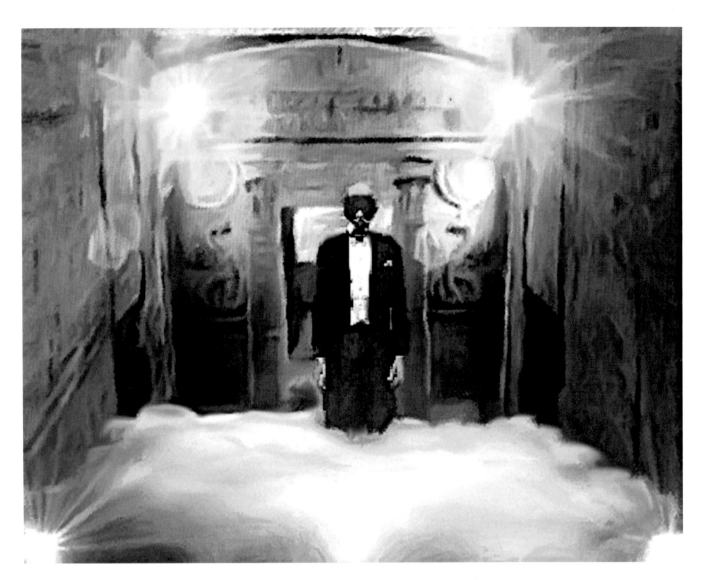

SOUND & LIGHT SHOW

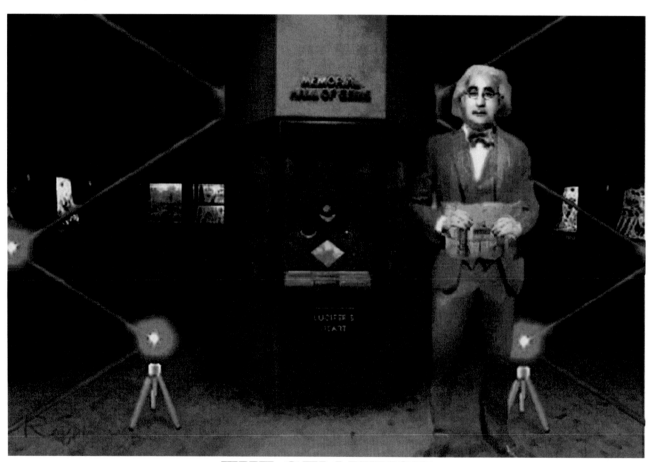

THE GEM HEIST

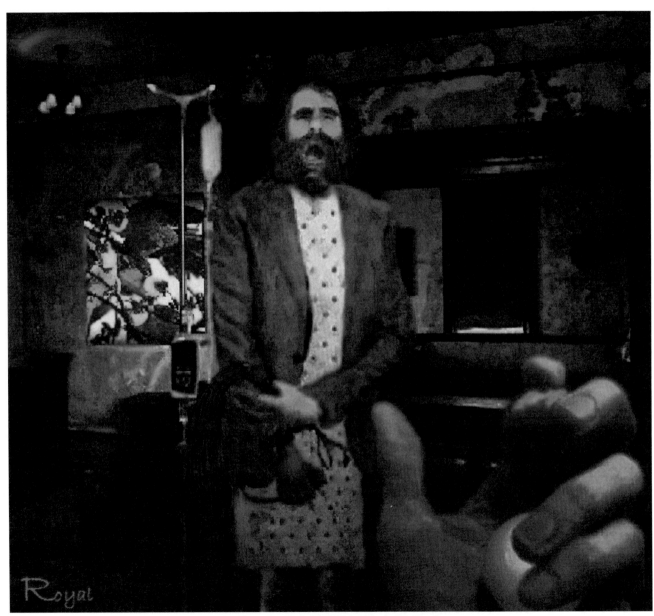

BILLIARD BALLS

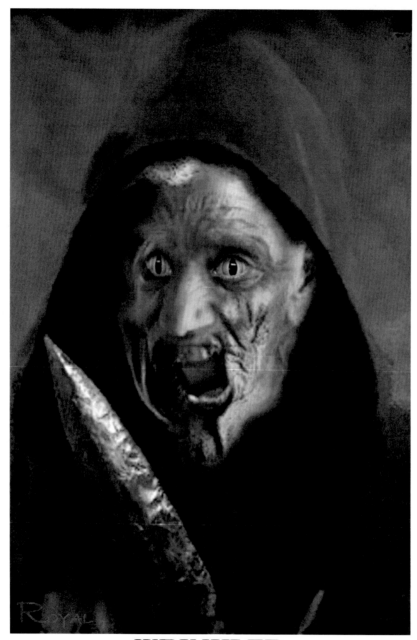

WRINKLER

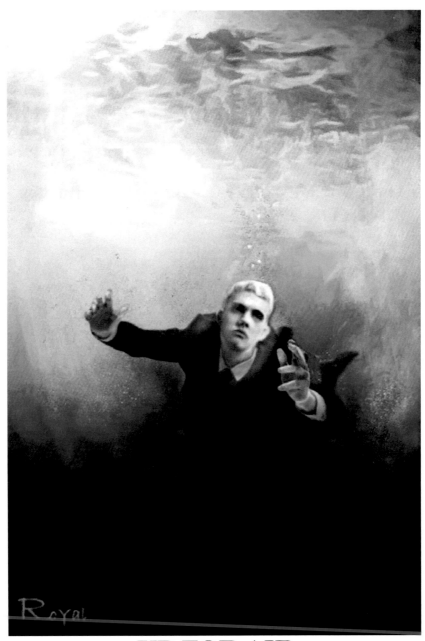

UP FOR AIR

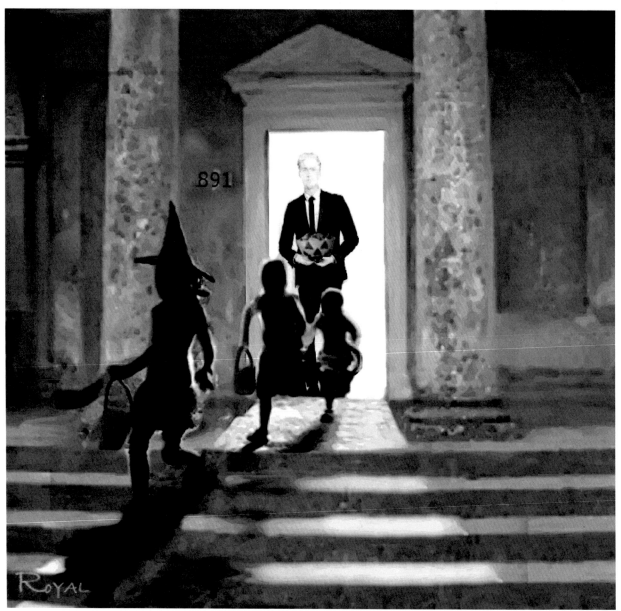

TRICK OR TREAT

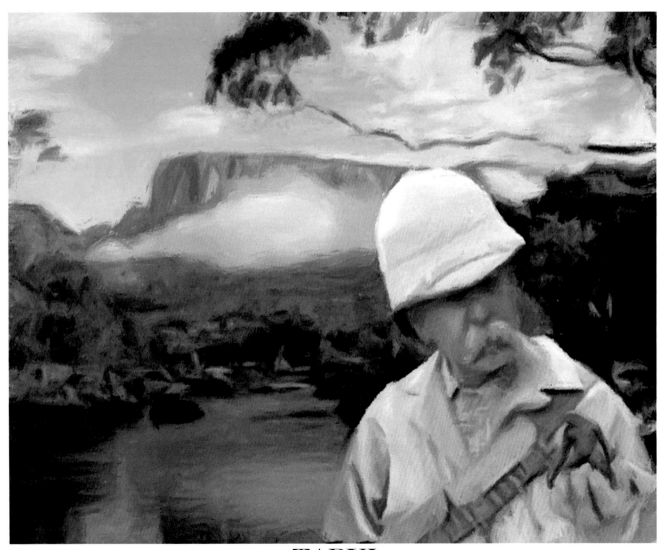

TAPUI

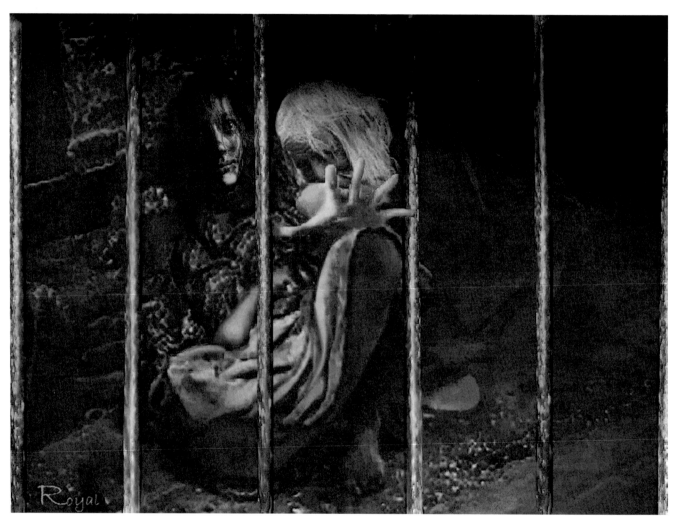

BREEDERS

11764631R00080

Made in the USA
San Bernardino, CA
08 December 2018